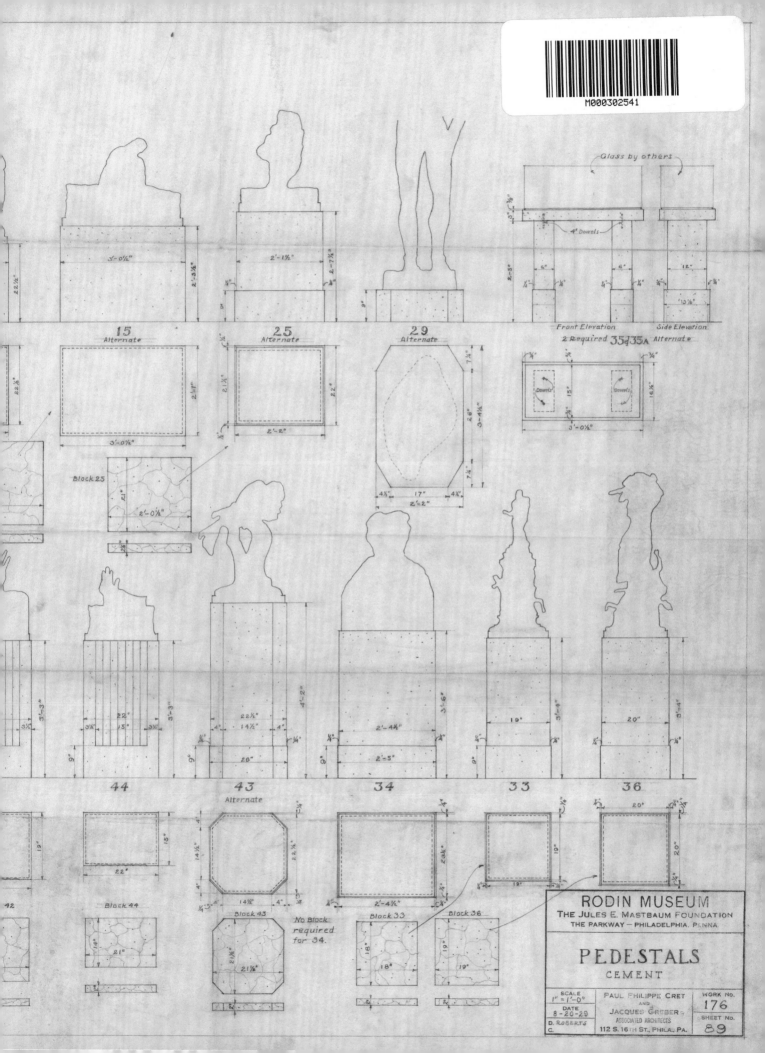

15
Alternate

25
Alternate

29
Alternate

Glass by others

4" Dowels

Front Elevation Side Elevation
2 Required 35 & 35A Alternate

Block 25

Dowels Dowels

44 43 34 33 36

Alternate

No Block
required
for 34.

Block 44 Block 43 Block 33 Block 36

RODIN MUSEUM
THE JULES E. MASTBAUM FOUNDATION
THE PARKWAY — PHILADELPHIA, PENNA.

PEDESTALS
CEMENT

SCALE 1" = 1'-0"	PAUL PHILIPPE CRET AND JACQUES GREBER ASSOCIATED ARCHITECTS 112 S. 16TH ST., PHILA., PA.	WORK NO. 176
DATE 8-20-29		
D. ROBERTS C.		SHEET NO. 89

RODIN MUSEUM

PHILADELPHIA

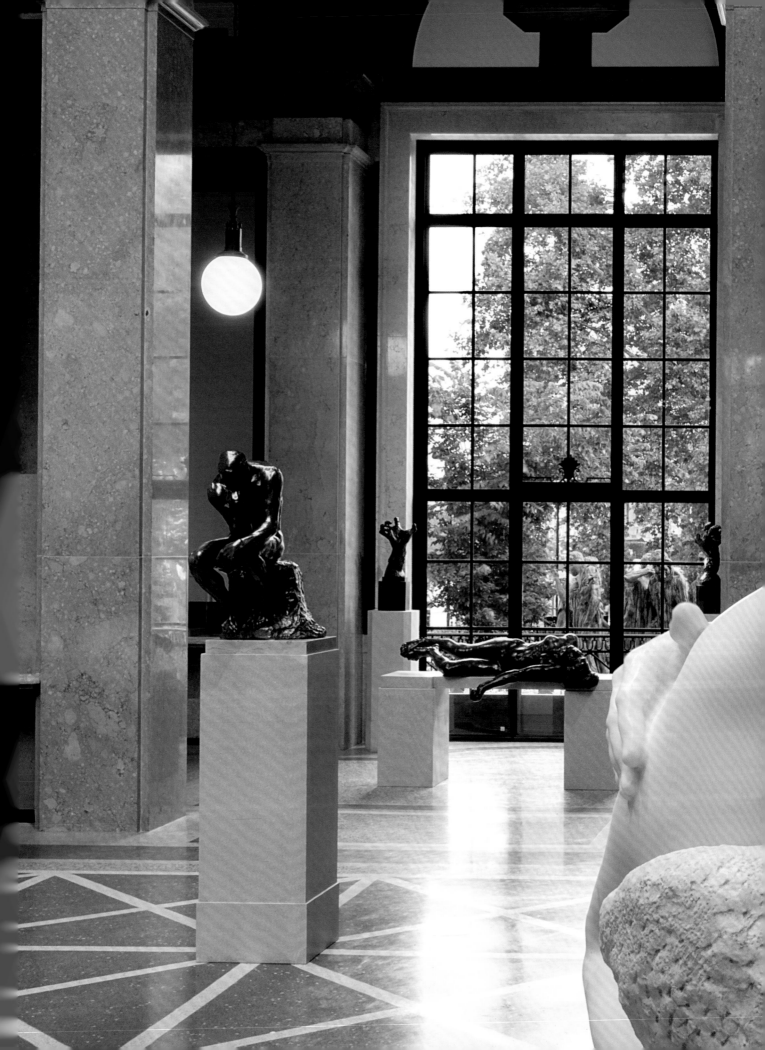

RODIN MUSEUM

PHILADELPHIA

JENNIFER A. THOMPSON

Color photography by Graydon Wood

PHILADELPHIA MUSEUM OF ART

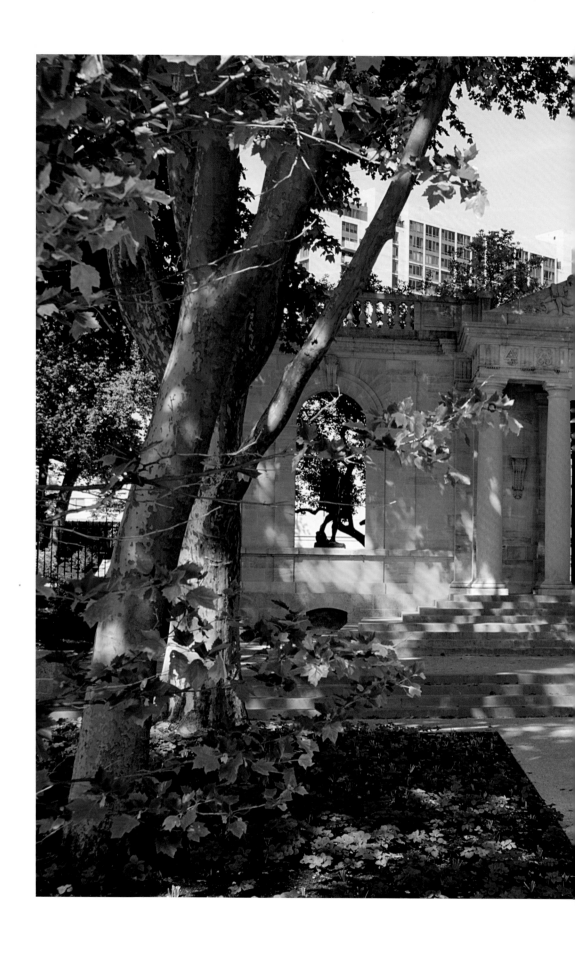

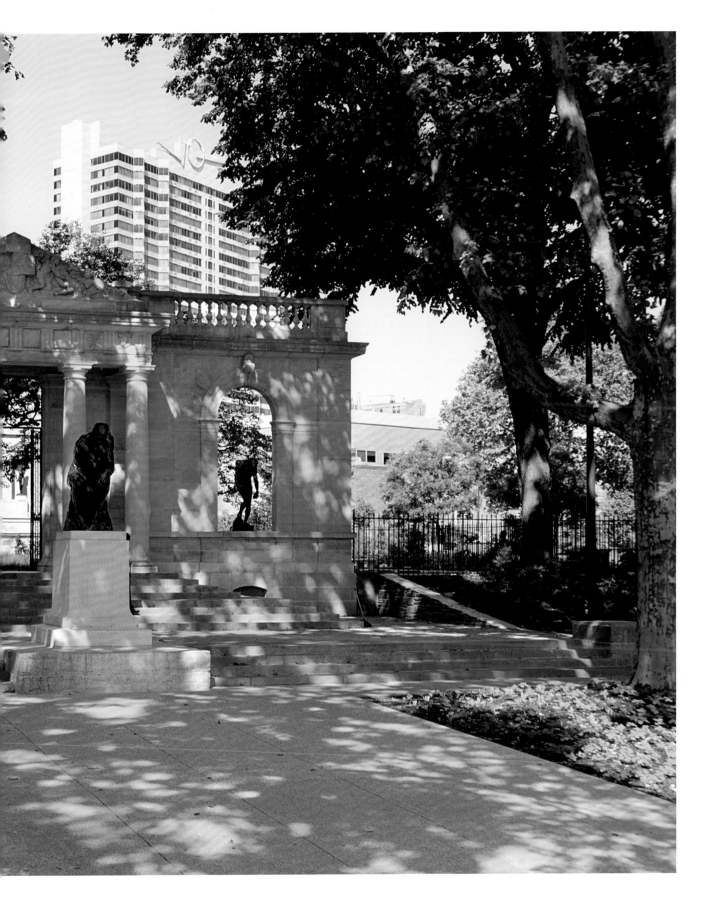

The Thinker at the entrance to the Rodin Museum, with *Adam* (left) and *The Shade* (right) in the arches of the Meudon Gate

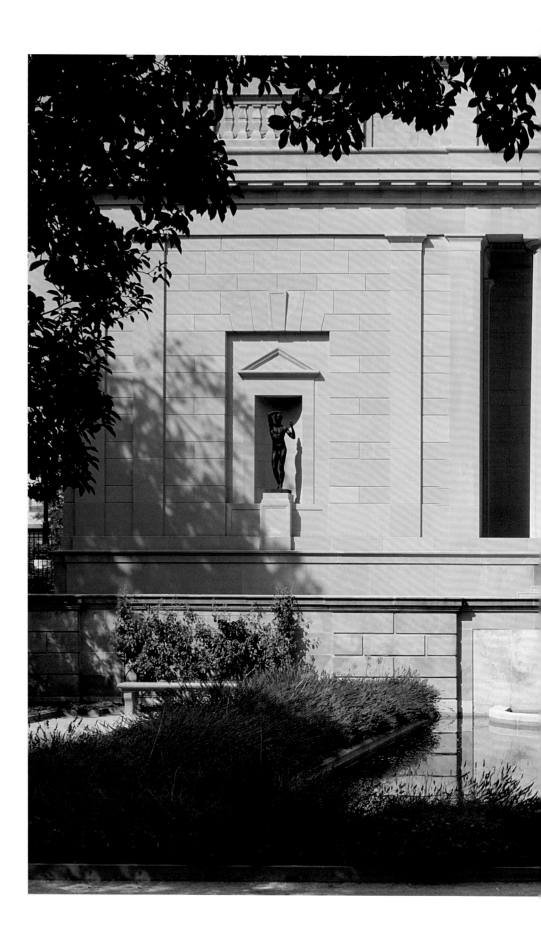

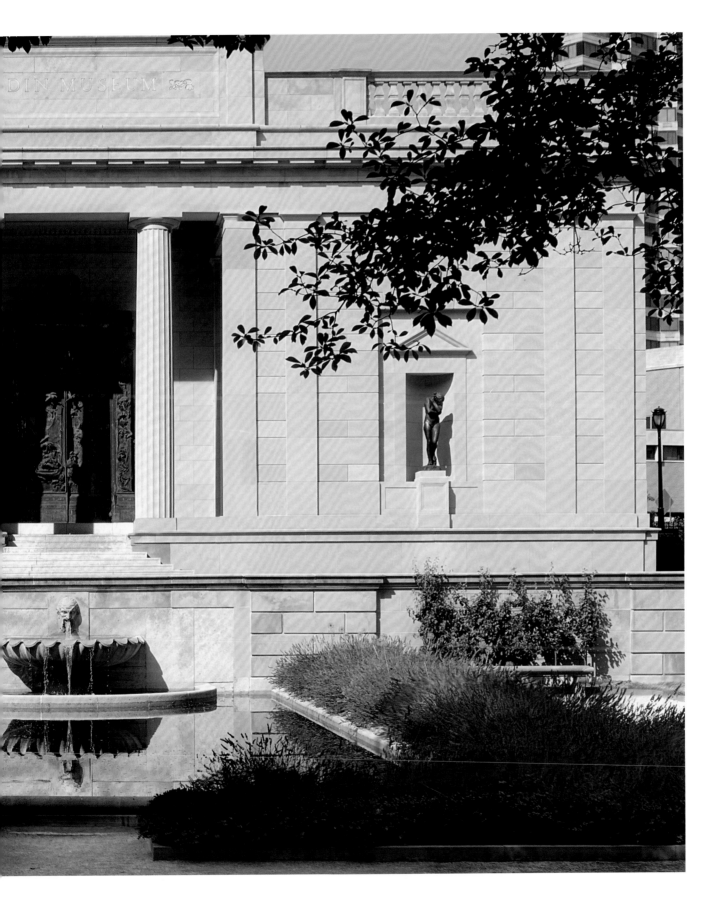

The Rodin Museum with *The Age of Bronze*, *The Gates of Hell*, and *Eve* (left to right) in the façade

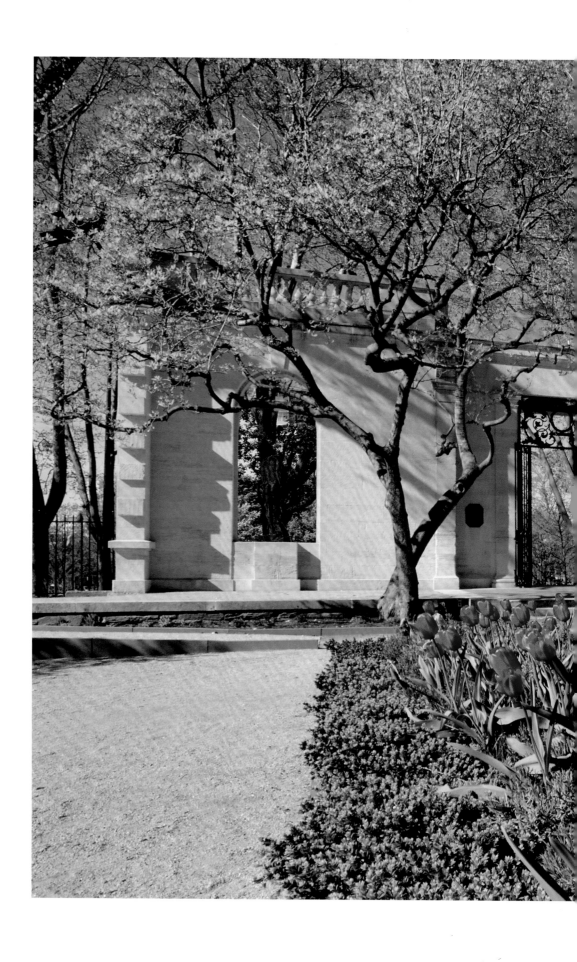

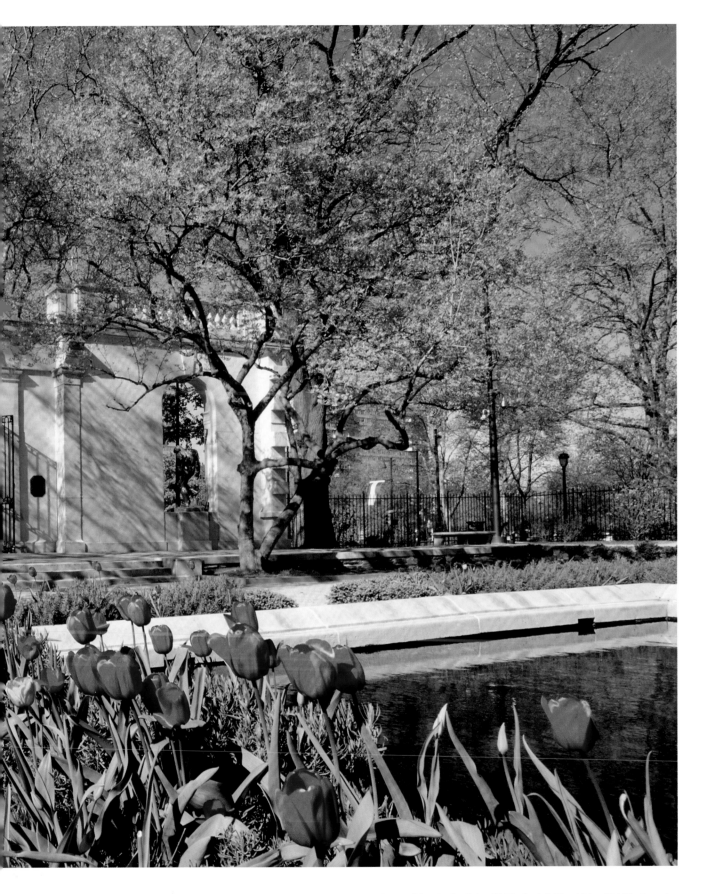

Back view of the Meudon Gate with *The Shade* (left) and *Adam* (right) in the arches

9

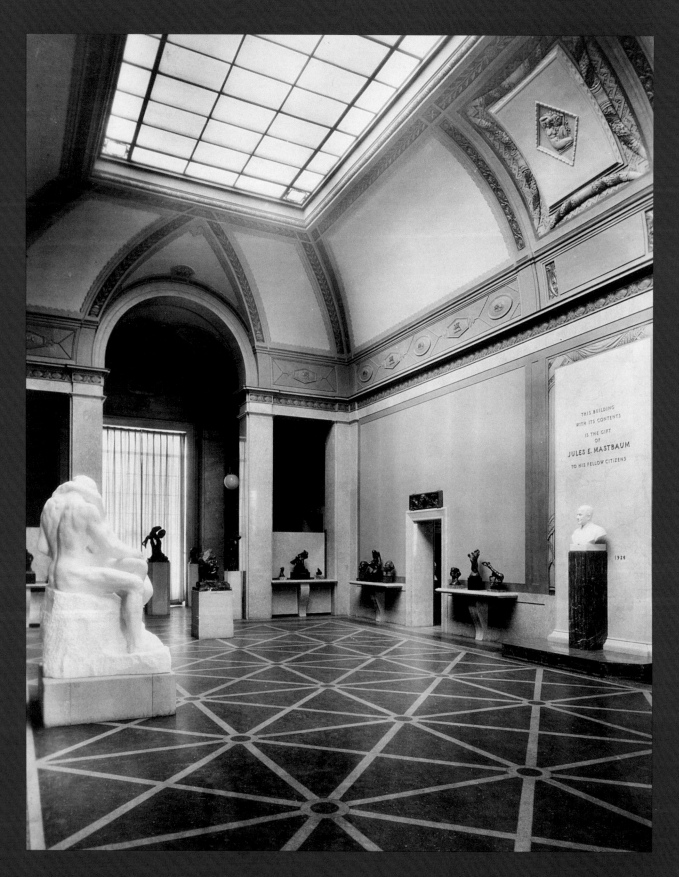

Fig. 1 Interior of the Rodin Museum, c. 1930 (Photographs; Rodin Museum Records; Philadelphia Museum of Art, Archives)

JENNIFER A. THOMPSON

"FOR THE STUDY AND ENJOYMENT OF MY FELLOW CITIZENS"

Jules Mastbaum's Gift to the City of Philadelphia

Nestled among the leafy trees lining the Benjamin Franklin Parkway—Philadelphia's ode to the Champs-Élysées in Paris—is the Rodin Museum, a jewel-like institution presented to the city in the 1920s by the philanthropist and cinema magnate Jules Mastbaum. Visitors are greeted by the brooding figure of *The Thinker* (cover) and climb a series of broad steps behind him, passing through a sculpture-filled façade and entering a formal French garden. Gravel paths bordered by flowerbeds and magnolia trees frame a reflecting pool and a crisp Beaux-Arts–style museum building (see pp. 6–7). Eight monumental bronze sculptures punctuate the garden, inviting study from multiple angles and in changing light and seasons. Inside the museum, beautifully proportioned galleries with abundant natural light provide an elegant setting for Mastbaum's distinguished collection of bronzes, marbles, and plasters by the renowned French sculptor Auguste Rodin.

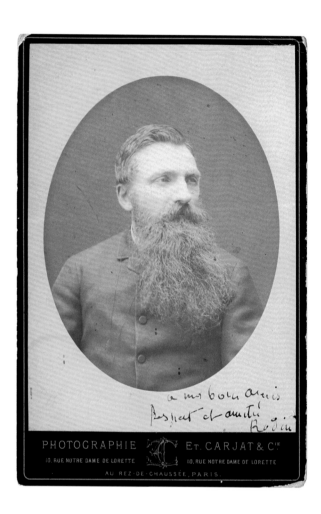

Fig. 2 Auguste Rodin, c. 1879 (Etienne Carjat & Cie carte de visite) (Rodin Museum curatorial files, Department of European Painting, Philadelphia Museum of Art)

Auguste Rodin

In a career that spanned the late nineteenth and early twentieth centuries, Auguste Rodin (1840–1917) (fig. 2) was deeply inspired by tradition yet rebeled against its idealizing standards, introducing innovations that paved the way for modern sculpture. He believed that art should be true to nature, a philosophy that shaped his attitudes to models and materials. His predilection for working with untrained models, who were imperfect in appearance and able to assume unconventional poses, allowed him to explore a range of expression and use the human body to convey internal states and feelings. Equally, Rodin's intense sense of materiality led him to produce works with rough, modulated surfaces that do not attempt to hide signs of their modeling or craftsmanship.

Rodin received his education and training in Paris in the 1860s at the École Spéciale de Dessin et de Mathématiques (known as the Petite École), having failed entry into the more prestigious École des Beaux-Arts. He then entered a long period of employment in the studio of the respected academic sculptor Albert-Ernest Carrier-Belleuse (1824–1887) (see pl. 11). In 1876 he traveled to Italy to study the work of Michelangelo, "my master and my idol," and learn the secrets behind the dramatic power of his nude sculptures.[1] Rodin's first critical success as an independent sculptor came in the late 1870s with *Saint John the Baptist Preaching* (pl. 7), a larger-than-life figure—whose model was an Italian peasant—that captures the entire movement of a step from beginning to end. Critics soon began to reappraise Rodin's earlier works, including the *Mask of the Man with the Broken Nose* (pl. 1) and *The Age of Bronze* (pl. 6), both of which had been heavily criticized, with the latter accused of being cast from life, a controversy that deeply troubled the artist and contributed to his increasing distortion and exaggeration of forms.

In 1880 Rodin received a highly prized commission to create a set of bronze doors for a new museum of decorative arts in Paris. The project, known as *The Gates of*

Hell, dominated his work for nearly three decades as he obsessively explored in sculptural form the stories of pain, suffering, and despair described in Dante Alighieri's poem *The Divine Comedy*. *The Gates of Hell* demonstrates powerfully the artist's ambitions for monumental sculpture, his debt to the past, and his raw, modern exploration of emotion, bodily distortion, and chaos (see pl. 14).

As did many of his contemporaries, Rodin eagerly sought government-sponsored commissions, recognizing them as an important means of establishing his reputation and advancing his artistic ideas. Large-scale public monuments honoring Honoré de Balzac (pl. 47), Claude Lorrain (pl. 44), and the Burghers of Calais (pl. 32) brought Rodin both fame and controversy, since his working method was protracted and unconventional, and he tended to emphasize the humanity of his subjects over their achievements or heroism. These contracts allowed him to establish an active studio and employ assistants to help in the production of large bronze and marble sculptures.

Throughout his career Rodin worked at a feverish pace, undertaking multiple projects at once and creating hundreds of clay models that explore different aspects of a human body, expression, or drapery. This practice left him with unused figures and fragments that he mined later, recombining them in new and unexpected ways (see pl. 34). Among Rodin's contributions to modern art was the presentation of fragments or partial figures as complete, finished works, as seen in his dramatic and moving sculptures of hands (see pls. 33, 49–51, 54).

By the end of the nineteenth century, Rodin was internationally recognized for the boldness and originality of his work, and he began to receive commissions from Argentina, England, and the United States. Collectors eagerly sought examples of his most noted works, including *The Thinker* (pl. 13) and *Eternal Springtime* (pl. 21), which were available in bronze, plaster, or marble versions during his lifetime. At his death in 1917, Rodin was heralded as "the father of modern sculpture," and his achievements inspired younger sculptors such as Camille Claudel, Henri Matisse, Constantin Brancusi, and Jacques Lipchitz.

In the final year of his life, Rodin gave the contents of his studio to the French state in order to establish a museum in the handsome eighteenth-century Hôtel Biron in Paris, where he had rented studio space. It was at the Musée Rodin in September 1924, seven years after the artist's death, that Jules Mastbaum of Philadelphia encountered the breadth of Rodin's work and hatched the idea of creating a museum devoted to him in Philadelphia.

Jules Mastbaum

Jules Ephraim Mastbaum (1872–1926) (fig. 3) was born at Thirteenth and Green Streets in Philadelphia and attended public schools before entering the Wharton School at the University of Pennsylvania. As a young man he worked for Gimbel Brothers department store and later established the successful real estate firm Mastbaum Brothers and Fleisher with his younger brother Stanley V. Mastbaum and their partner Alfred W. Fleisher. During the course of their real estate venture, the Mastbaum brothers became fascinated by the burgeoning motion picture business and opened their first theater in Philadelphia in 1905.[2]

They shortly established additional theaters throughout the city, placing them near streetcar lines and hiring the firm of Hoffman and Henon to design lavish interiors with comfortable seating and space for full orchestras. Following Stanley Mastbaum's sudden death in 1918, the business was named the Stanley Company of America and began to grow at a rapid pace, acquiring cinemas in New York, Washington, and Pittsburgh. By 1926, the Stanley Company was the largest operator of theaters in the United States, with more than 250 venues along the East Coast, and Jules Mastbaum was heralded as "the

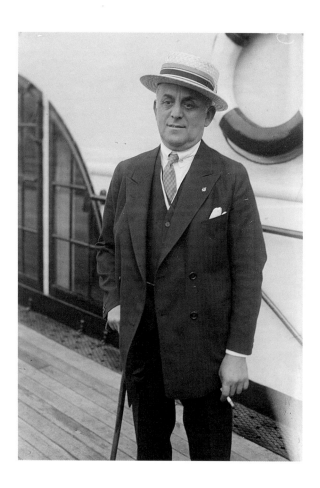

king of cinema." An avid golfer who enjoyed sports and owned the Philadelphia Arena, he was also a prominent philanthropist who gave generously to the Federation of Jewish Charities, medical research, and other causes. Mastbaum's interest in art was not widely known until 1924, when he began an intense period of activity as a collector of works by Rodin.

Earlier, in 1922 and 1923, Mastbaum had assembled a modest collection of small French bronzes by artists such as the animalier Antoine-Louis Barye (1796–1875), one of Rodin's early teachers. He relied on advisors like Albert Rosenthal (1863–1939), a Pennsylvania painter and lithographer who acquired several bronzes for him in Paris, or the American-born painter Gilbert White (1877–1939), who painted Mastbaum's portrait in 1923 and accompanied him to the Musée Rodin the following year.[3] In Philadelphia, Mastbaum had other opportunities to learn about Rodin; he belonged to the same sporting club as Samuel S. White, 3rd, a Philadelphia body builder and later dental supply manufacturer who had posed for Rodin's *The Athlete* in 1901 (pl. 43). Mastbaum probably also knew the marbles by Rodin on public view in Philadelphia: the tragic figure of a Danaid collapsed on her rock at the Pennsylvania Academy of the Fine Arts (later acquired by the Philadelphia Museum of Art; see pl. 20), and three works purchased directly from the artist by the Philadelphia lawyer John G. Johnson (1841–1917), among them the enigmatic marble portrait titled *Thought*, which represents Rodin's mistress and fellow sculptor Camille Claudel (pl. 42).

Mastbaum's initial visit to the Musée Rodin in the autumn of 1924 marked the beginning of a warm friendship with the curator, Léonce Bénédicte (1859–1925). According to the artist's expressed wish, the museum was authorized to produce new bronze casts of his works following his death,[4] and the Philadelphian left after his first visit with a bronze bust by Rodin under his arm and an order for seven additional bronze casts, including *Meditation* (pl. 29) and a medium-sized version of *The Thinker* (pl. 13).[5] These small-scale works, representing some of the artist's most popular compositions, were most likely intended for

Mastbaum's home or office. Six months later, in February 1925, Mastbaum placed a second order for nineteen sculptures (including pls. 1, 9, 15, 49), reflecting greater ambition and boldness in their subjects and sizes. Most of Mastbaum's bronzes were posthumous casts, authorized by the Musée Rodin. The bronzes produced for Philadelphia are of extremely fine quality, having been made by the Parisian foundry of Alexis Rudier, which had worked with Rodin for many years and knew his exacting standards. Mastbaum briefly considered placing these sculptures, mainly portraits of historical figures, in Stanley Company theaters so that Rodin might be appreciated by a broader audience.[6]

Within the year, however, Mastbaum's ambitions for the collection advanced; he acquired more than one hundred additional sculptures, including monumental works such as *The Thinker* (cover) and *The Burghers of Calais* (pl. 32).[7] Others were more appropriate for a gallery setting and explored lesser known aspects of Rodin's career. Some, like *Shame (Absolution)* (pl. 28), bas-reliefs for *The Gates of Hell* (pls. 26, 27), and *Two Hands* (pl. 51), were unique selections, and no other bronze casts of these works exist today. Simultaneously, Mastbaum and Rosenthal began to work with the art dealers F. & J. Tempelaere in Paris to acquire a range of marbles, plasters, drawings, and an early sketchbook (pl. 5) by Rodin with the goal of assembling a diverse and comprehensive view of his work.

In December 1925, Mastbaum placed a bold and historic order for a bronze cast of *The Gates of Hell* (pl. 14). Rodin had worked on plaster models of the doors for nearly 37 years, continually refining and modifying its 227 figures that writhe in pain and torment. The Paris museum for which *The Gates of Hell* was intended as a majestic portal was not built, and Rodin himself was never quite ready to declare them finished. The first two curators of the Musée Rodin, Léonce Bénédicte and his successor Georges Grappe (1879–1947), were eager to realize Rodin's seminal work in bronze and tried to convince several collectors to do so. A Japanese businessman, Kojiro Matsukata, agreed to purchase a bronze version of *The Gates of Hell* in 1920 for a museum he was building in Tokyo, but heavy import taxation meant that he could not follow through immediately with his order.[8] Five years later Jules Mastbaum became the first individual to acquire *The Gates of Hell* when he purchased two casts: one for Philadelphia and the other for the Musée Rodin in Paris.

A Rodin Museum for Philadelphia

As his collection grew, Mastbaum began to press the Musée Rodin to allow him to acquire some plasters, among the most extraordinary and revealing examples of the sculptor's working practice. Rodin modeled his sculptures primarily in wax and clay, and regularly had these fragile materials cast in plaster in order to preserve them. Bénédicte had promised to include plasters as gifts with Mastbaum's larger orders, but the curator's death in May 1925 meant that his successor was left to fulfill these verbal agreements. Grappe and the board of the Musée Rodin were understandably concerned about giving away unique pieces by Rodin, but Mastbaum was persistent in wanting the plasters so that "the work of that great master can be appreciated and the desire for the study of his great works can be stimulated."[9] Eager to work with the American collector, Grappe eventually persuaded the board to present a group of plasters to Mastbaum (see pls. 35, 36, 39). Among them was a copy of Rodin's *Third Architectural Model for "The Gates of Hell,"* a terracotta study created about 1881–82 that documents his shift from thinking of the doors as a series of rectangular narrative scenes to an increasingly organic and chaotic surface watched over by the poet Dante (pl. 12).

Mastbaum's collection was first shown publicly in 1926 at the Sesqui-Centennial Exposition in Philadelphia (fig. 5), and the large *Thinker* was installed in Logan Square the same year (fig. 6), but he had much grander plans

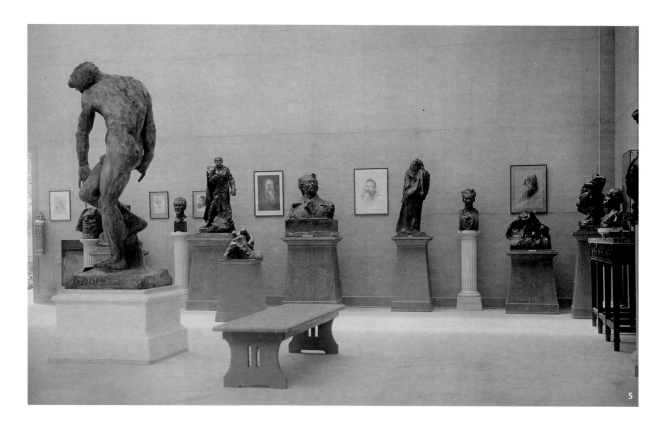

Fig. 5 The Jules E. Mastbaum collection as shown in the Sesqui-Centennial Exposition in Philadelphia, June to November 1926; photography by W. Coulbourn Brown (Rodin Museum curatorial files, Department of European Painting, Philadelphia Museum of Art)

Fig. 6 Jacques Gréber next to *The Thinker* in Logan Square, Philadelphia, July 2, 1926 (McDowell Bulletin Collection, P066224, Urban Archives, Temple University Libraries, Philadelphia)

Fig. 7 Paul Philippe Cret, 1910; photograph by Haeseler (Paul Philippe Cret Collection, aaup.062.448, Architectural Archives, University of Pennsylvania, Philadelphia)

Fig. 8 Rodin's funeral at Meudon, November 24, 1917; photograph by Pierre Choumoff (Musée Rodin, Paris, Ph. 1009)

Fig. 9 Jules Mastbaum (center) with Baron Arthur Chassériau (left) and Georges Grappe (right) in front of Rodin's tomb in Meudon, July 25 or 26, 1926 (Musée Rodin, Paris, Ph. 6634)

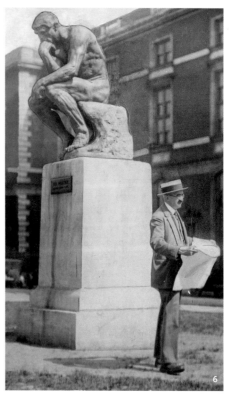

and in late 1925 had begun to think seriously about sharing his collection more permanently with the public. In April 1926 Mastbaum approached the Fairmount Park Commission with plans to build and maintain at his own expense a museum on the Benjamin Franklin Parkway, in which his collection would be "freely available for the study and enjoyment of my fellow citizens of Philadelphia."[10] With the commission's approval and with the block of the Parkway between Twenty-first and Twenty-

home outside Paris. Rodin had purchased the ruins of the château in 1907 and transported the stones to nearby Meudon, where portions of them were reassembled on a hillside overlooking Paris. At his death in 1917, Rodin and his wife Rose Beuret were buried in front of the façade, beneath a large cast of *The Thinker*, while full-size plaster sculptures of *Adam* and *The Shade* stood in the arches of the façade, watching the crowds at his funeral (fig. 8). Mastbaum was deeply moved by Rodin's

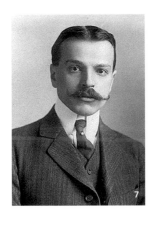
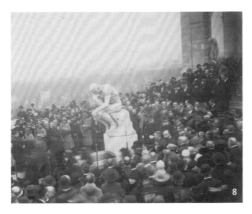
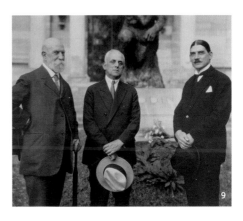

second Streets reserved for this project a month later, Mastbaum hired two acclaimed French architects to collaborate on the design: Jacques Gréber (1882–1962) (fig. 6) and Paul Philippe Cret (1876–1945) (fig. 7). Both had extensive experience working in Philadelphia; nearly a decade earlier Gréber had been responsible for completing the design of the Parkway and envisioning a series of gardens to line it, while Cret had recently designed a gallery for Dr. Albert Barnes in Merion and was in charge of the renowned architecture school at the University of Pennsylvania.[11] Although Cret and Gréber had both attended the École des Beaux-Arts in Paris, they had never worked together but would become close collaborators on the Philadelphia project. Mastbaum's vision for the site included several components that would remain constant: an entry portal based on Rodin's grave at Meudon, a garden filled with large bronzes, and a central building to display the remainder of the collection (see fig. 11). He was committed to replicating the façade of the late-seventeenth-century Château d'Issy-les-Moulineaux as it appeared at Rodin's

tomb and was photographed standing in front of it with Grappe and Baron Arthur Chassériau, chairman of the board of the Musée Rodin, in July 1926 (fig. 9). The same month Gréber's Paris office made an exact drawing of the château's façade, carefully measuring each stone so that it could be reproduced in Philadelphia (fig. 10).

Mastbaum already owned examples of Rodin's monumental sculptures, well suited for display in the garden, but he was frustrated by the scarcity of large-scale marbles for the interior. In August 1926, he wrote to the Musée Rodin with an unusual request for permission to have a marble copy of Rodin's *The Kiss* made for the museum in Philadelphia (pl. 55). The Musée Rodin agreed, with the provision that the replica be labeled as such, and they supplied a plaster cast to serve as a model for the sculptor who would produce the copy—Henri Gréber (1855–1941), Jacques Gréber's father. Mastbaum selected *The Kiss*, believing it "perhaps the finest group in marble by Rodin," and he presumably knew of its connection with *The Gates of Hell*.[12] Rodin had originally intended the

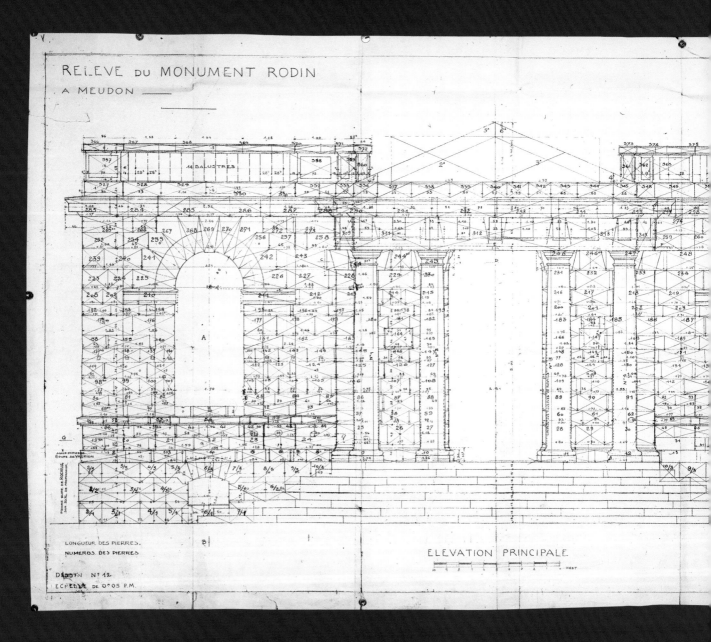

Fig. 10 Architectural study for the Meudon Gate by Jacques Gréber, July 1926
(Cret Collection, 27-PS-176-015, The Athenaeum of Philadelphia)

figures to represent Paolo Malatesta and Francesca da Rimini, a pair of lovers Dante had encountered in his poetic vision of hell, but the moment of bliss captured in Rodin's composition proved too cheerful a subject for the doors, and he removed them and enlarged the piece into an independent work.

During the summer and fall of 1926, Cret and Gréber submitted site designs to Mastbaum and Rosenthal, who had been appointed director of the museum. The plans reflected Beaux-Arts principles of symmetry and clarity, and the interior of the museum was organized to allow large windows and a skylight to bathe sculptures in natural light (fig. 1). Classical motifs were evident in the ornament, such as the Greek Doric columns flanking the central portico holding *The Gates of Hell*; the griffins, dolphins, Apollo and his horse-drawn chariot, and nymphs bearing baskets of fruit decorating the interior friezes; and the richly patterned terrazzo floor. Smaller corner galleries and a wood-paneled library on the north side of the building were designed as intimate spaces for the display of drawings and the ephemeral material that Mastbaum had assembled.

In late 1926 the design was undergoing its final refinements, limestone for the Meudon Gate had been ordered from France, and plans were being made for a ground-breaking ceremony when Mastbaum died unexpectedly on December 7 of complications following a recent surgery. After a period of uncertainty, during which Rosenthal resigned his position as director, the collection was locked in a storage room of a Stanley Company theater, and the architects were forced to trim costs and agree to a $325,000 price tag for the building and garden, Mastbaum's widow, Etta, and his three daughters stepped forward to realize the museum (see fig. 4). Construction began in December 1927 and was largely finished by January 1929, when *The Gates of Hell* arrived from Paris. During the summer of that year, the Rodin sculptures were brought out of storage, and terrazzo pedestals were carefully designed by the architectural office of Cret and Gréber (see endpapers). Before the museum opened, Mrs. Mastbaum announced a significant change from her husband's original intentions: rather than maintaining the building and continuing to own the collection, she would give the museum and its contents outright to the

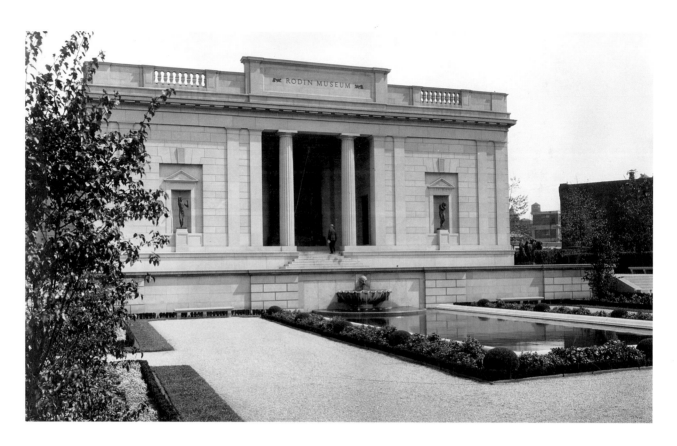

Fig. 11 Exterior of the Rodin Museum, c. 1930 (Photographs; Rodin Museum Records; Philadelphia Museum of Art, Archives)

city of Philadelphia, which would then be responsible for its care and upkeep. The city asked the Philadelphia Museum of Art, housed in a new building just a few blocks down the Parkway, to oversee and administer the Rodin Museum, a task that was embraced by the art museum's director, Fiske Kimball, and Francis Henry Taylor, its curator of decorative arts.

At the inauguration of the Rodin Museum on November 29, 1929, Paul Claudel, the French ambassador and younger brother of Camille Claudel, awarded his country's prestigious Légion d'honneur to Etta Mastbaum in recognition of her efforts to promote an understanding of French sculpture in the United States. In the central gallery of the museum was a memorial to its patron and founder, a marble bust of Mastbaum with an inscription celebrating his gift to his fellow citizens (see fig. 1).

The Rodin Museum was enthusiastically embraced by Philadelphians, over 390,000 of whom visited in its first year. In the decades since, Mastbaum's desire that it encourage scholarship and appreciation of Rodin's oeuvre has been met through thoughtful exhibitions, reinstallations, publications, and interpretive materials.[13] The collection has been enhanced through individual gifts and purchases: a plaster of *Eternal Springtime* originally presented by Rodin to the Scottish poet Robert Louis Stevenson (pl. 21); a plaster model of a naked Balzac, one of several that Rodin produced as studies for the monument; a rare wax study for a monument to the French Revolution that Rodin never pursued (pl. 10); and a marble of *Young Mother in the Grotto*, a deeply poignant maternal subject (pl. 18).

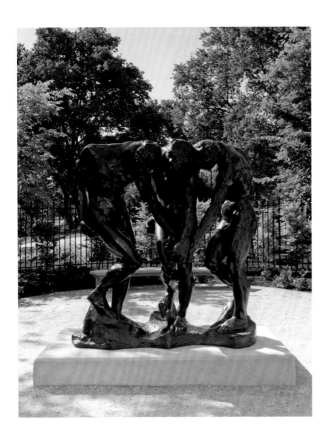

Fig. 12 *The Three Shades* installed in the Rodin Museum garden, 2012 (modeled in clay 1881–86, enlarged 1901–4; cast in bronze 1983; lent by Iris and B. Gerald Cantor)

In the early twenty-first century, as the Rodin Museum entered its eighth decade, the building and garden were painstakingly renovated and replanted in order to restore the character of their original appearances and to ensure the continued enjoyment of visitors. The exterior sculptures, most of which had been moved indoors in the 1960s, were returned to the garden (see pp. 4–7, fig. 12), allowing the site to become once again an exquisite ensemble of sculpture, architecture, and landscape. Inside the building, careful research and analysis allowed original wall colors and surfaces, and even the curtains in the library, to be reproduced (see pp. 2–3, 22–23). In a city rich in public sculpture, the Rodin Museum offers residents and visitors a tranquil sanctuary in which to explore the work and impact of a single, pivotal artist vital to understanding modern sculpture.

The author wishes to thank Timothy Rub, The George D. Widener Director and Chief Executive Officer of the Philadelphia Museum of Art, as well as Susan K. Anderson, Joan Ash, Sherry Babbitt, Alice Beamesderfer, Richard Bonk, David B. Brownlee, Norma Brunswick, Mary Cason, Kathryn Costello, Lisa Benn Costigan, Kate Cuffari, Gail Harrity, Ryma Hatahet, Christine Hilger, Erin Lehman, Andrew Lins, Sally Malenka, Constance Mensh, Paul Pincus, Joseph J. Rishel, Jack Schlechter, Marla K. Shoemaker, Richard B. Sieber, James Wehn, Jason Wierzbicki, and Graydon Wood for their gracious assistance.

1 Ruth Butler, *Rodin: The Shape of Genius* (New Haven: Yale University Press, 1993), p. 98.

2 Some sources indicate that Felix Isman was an early partner of the Mastbaums in their movie theater business and that together they bought out the movie pioneer Siegmund Lubin. See Joseph P. Eckhardt, *The King of the Movies: Film Pioneer Siegmund Lubin* (Madison, NJ: Fairleigh Dickinson University Press, 1997), p. 81.

3 Gilbert White, in "Mastbaum Foundation: Rodin Museum of Philadelphie," *La Renaissance de l'art français et des industries de luxe*, November 1926, p. 600.

4 In about 1916 Rodin wrote, "I would like [my works] that exist only in plaster in Meudon to be cast in bronze in order to give my oeuvre an air of permanency." Quoted in Antoinette Le Normand-Romain et al., *The Bronzes of Rodin: Catalogue of Works in the Musée Rodin* (Paris: Éditions de la Réunion des Musées Nationaux, 2007), vol. 1, p. 35.

5 White, in "Mastbaum Foundation," p. 600.

6 Mastbaum to Oscar M. Stern, February 6, 1925, Administrative Records, Subgroup A; Rodin Museum Records; Philadelphia Museum of Art, Archives (hereafter cited as PMAA).

7 In the fall of 1924 Mastbaum wrote that "I also have an idea that even as large a piece as the Gates of Hell or a large size Thinker should be bought by the City of Philadelphia and placed on exhibition here for the public." Mastbaum to Oscar M. Stern, November 11, 1924, PMAA.

8 Le Normand-Romain, *Bronzes*, pp. 40–41.

9 Mastbaum to Oscar M. Stern, October 7, 1925, PMAA.

10 Mastbaum to Commissioners of Fairmount Park, April 15, 1926, PMAA.

11 David B. Brownlee, "Building the City Beautiful: Jacques Gréber in Philadelphia/O Movimento City Beautiful: Jacques Gréber em Filadélfia," in *Jacques Gréber: Urbanista e Arquitecto de Jardins/Urbanist and Garden Designer*, ed. Teresa Andresen, Manuel Fernandes de Sá, and João Almeida (Porto: Fundação de Serralves, 2011), pp. 134–61.

12 Mastbaum to Georges Grappe, August 30, 1926, PMAA.

13 See, for example, John L. Tancock's ground-breaking catalogue of the collection, *The Sculpture of Auguste Rodin: The Collection of the Rodin Museum, Philadelphia* (Philadelphia: Philadelphia Museum of Art, 1976), and the catalogue for the revelatory exhibition organized by Christopher Riopelle, *Rodin and Michelangelo: A Study in Artistic Inspiration* (Philadelphia: Philadelphia Museum of Art, 1997).

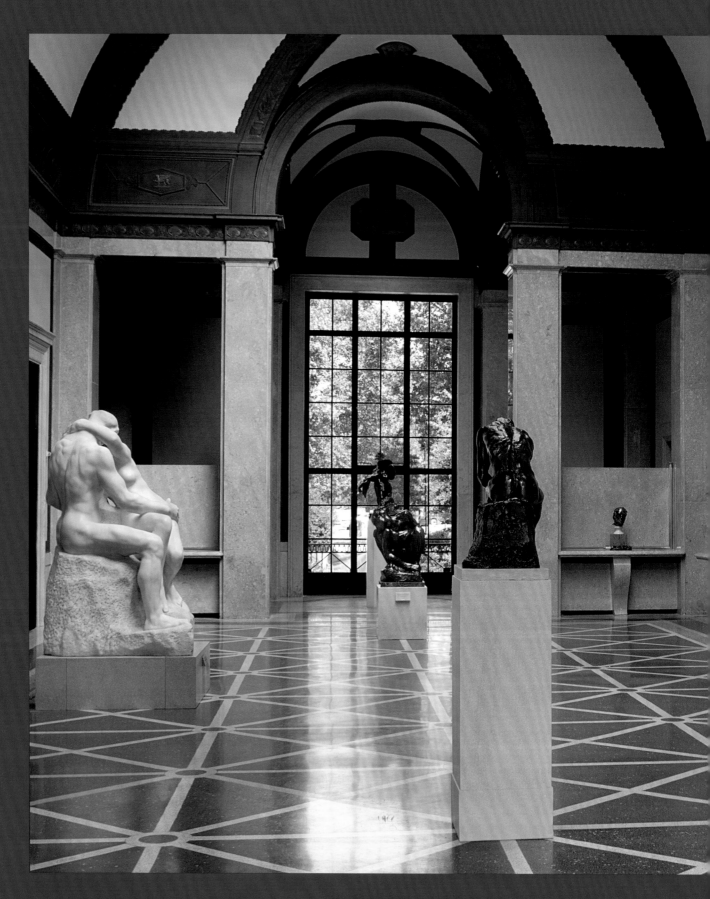

Interior of the Rodin Museum

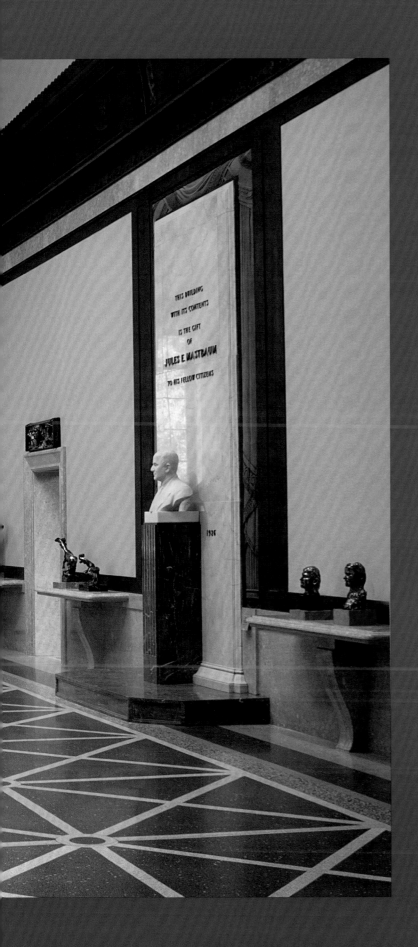

THIS BUILDING
WITH ITS CONTENTS
IS THE GIFT
OF
JULES E. MASTBAUM
TO HIS FELLOW CITIZENS

1926

These plates show a selection from the collection of nearly 150 sculptures.

1
Mask of the Man with the Broken Nose
Modeled in clay 1863–64
Cast in bronze 1925
10 1/4 x 6 7/8 x 9 3/4 inches (26 x 17.5 x 24.8 cm)
Bequest of Jules E. Mastbaum, F1929-7-55

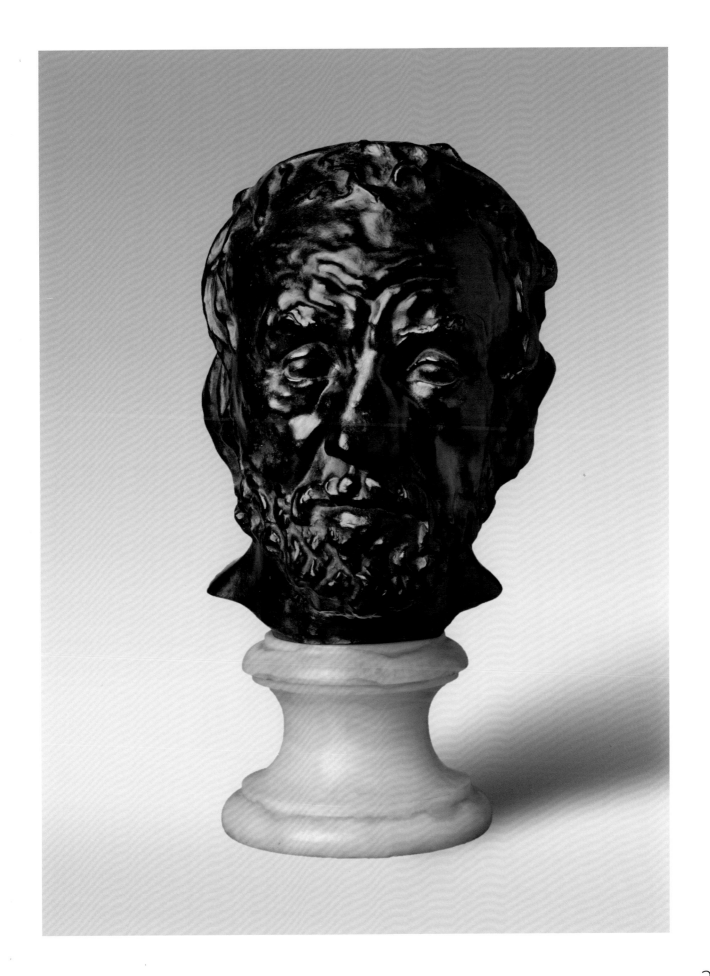

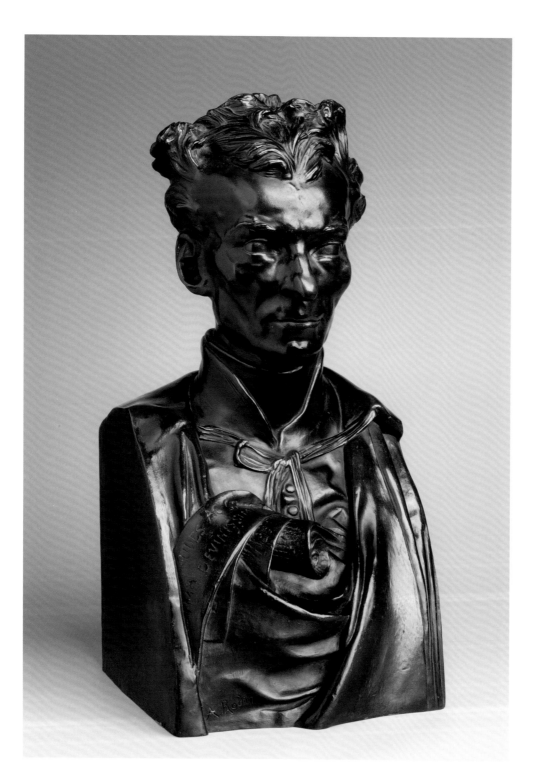

2
Father Pierre-Julien Eymard
Modeled in clay 1863
Cast in bronze 1925
22 3/4 x 11 x 10 1/2 inches (57.8 x 27.9 x 26.7 cm)
Bequest of Jules E. Mastbaum, F1929-7-51

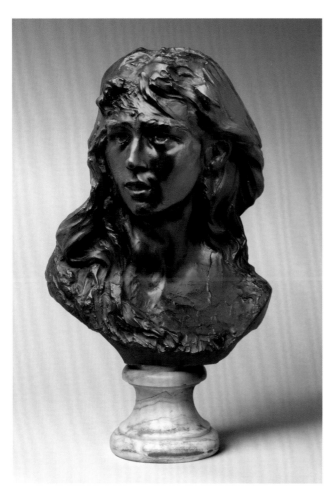

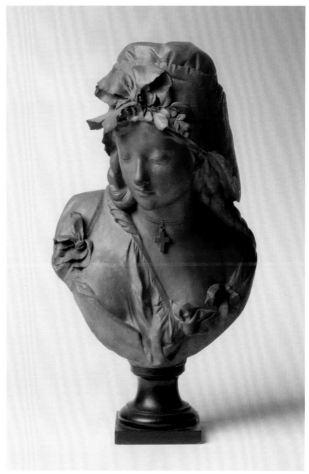

3
Mignon
Modeled in clay c. 1867–68
Cast in bronze 1925
15 1/2 x 12 x 19 1/2 inches (39.4 x 30.5 x 49.5 cm)
Bequest of Jules E. Mastbaum, F1929-7-10

4
La Lorraine
Modeled in clay and cast in terracotta, painted 1872–75
15 1/4 x 10 1/2 x 8 inches (38.7 x 26.7 x 20.3 cm)
Bequest of Jules E. Mastbaum, F1929-7-34

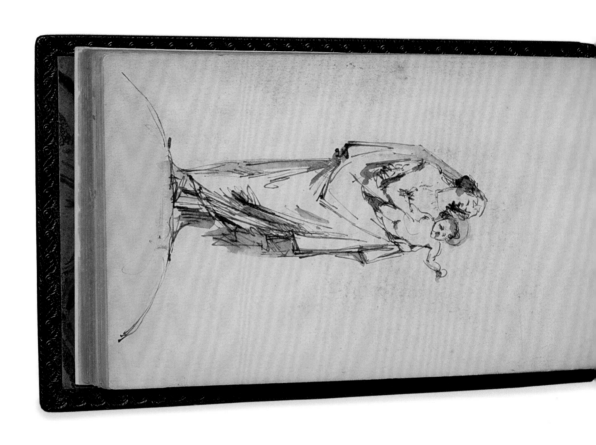

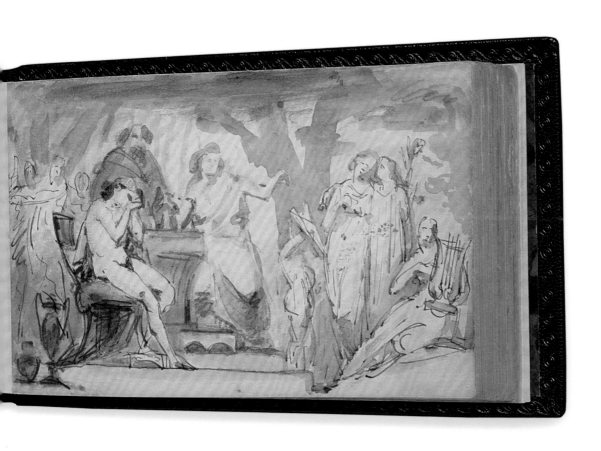

5
The Mastbaum Album
Sketchbook of drawings in graphite, ink, and wash,
bound in leather; c. 1860–80
Page 3 3/4 x 6 3/4 inches (9.5 x 17.1 cm)
Gift of Mrs. Jefferson Dickson, 1981-49-1

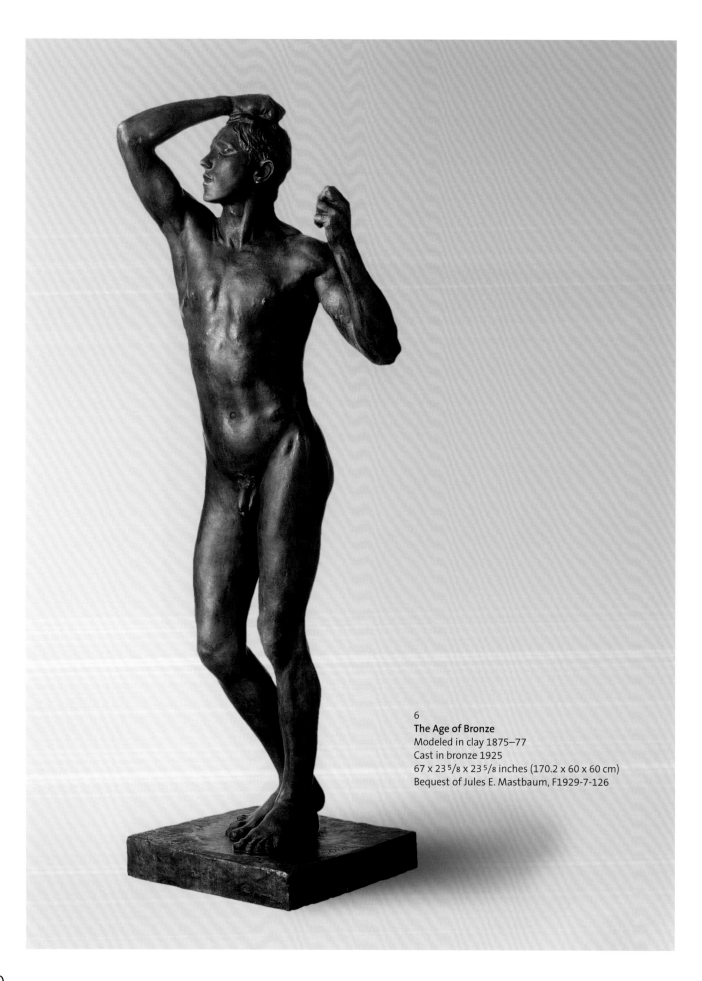

6
The Age of Bronze
Modeled in clay 1875–77
Cast in bronze 1925
67 x 23 5/8 x 23 5/8 inches (170.2 x 60 x 60 cm)
Bequest of Jules E. Mastbaum, F1929-7-126

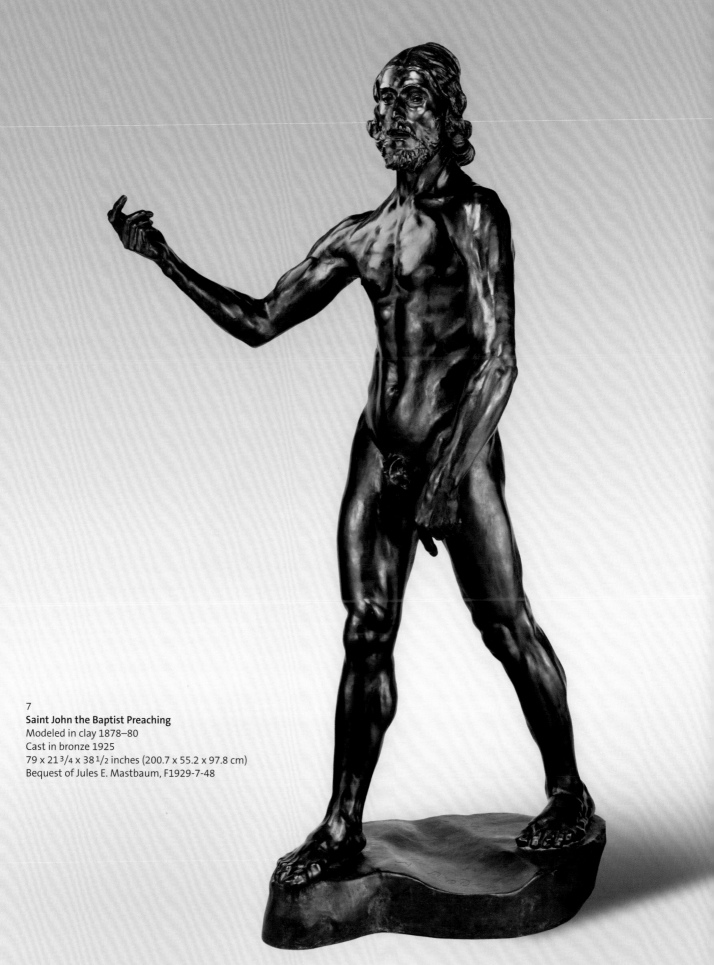

7
Saint John the Baptist Preaching
Modeled in clay 1878–80
Cast in bronze 1925
79 x 21 3/4 x 38 1/2 inches (200.7 x 55.2 x 97.8 cm)
Bequest of Jules E. Mastbaum, F1929-7-48

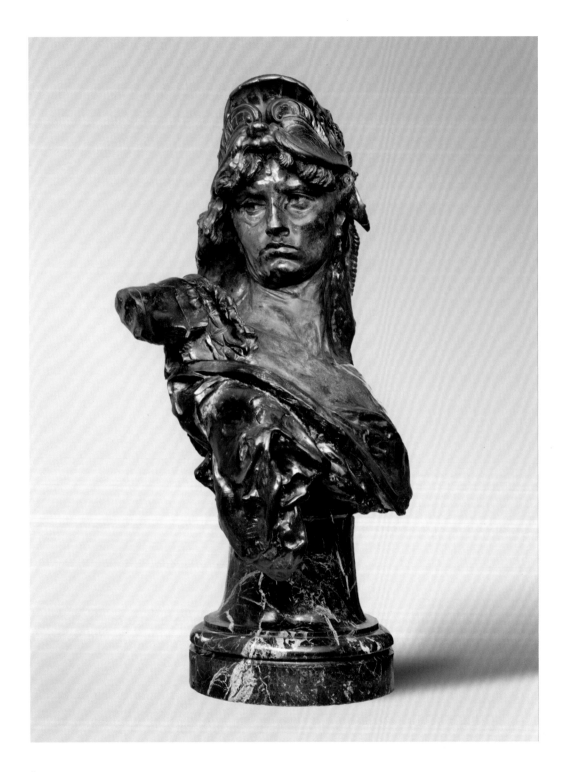

8
Bellona
Modeled in clay 1879
Cast in bronze 1925
30 1/2 x 22 3/4 x 14 1/2 inches (77.5 x 57.8 x 36.8 cm)
Bequest of Jules E. Mastbaum, F1929-7-71

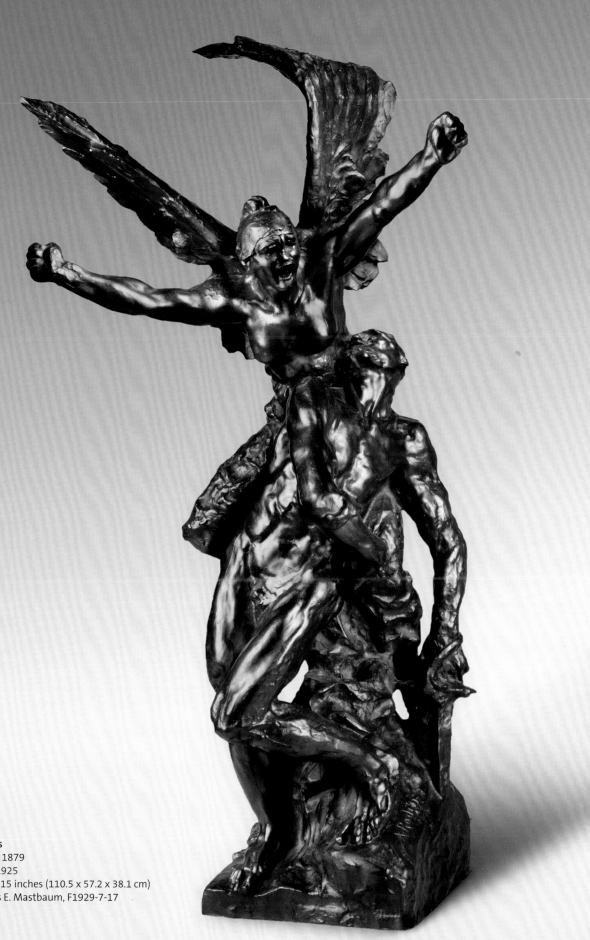

9
The Call to Arms
Modeled in clay 1879
Cast in bronze 1925
43 1/2 x 22 1/2 x 15 inches (110.5 x 57.2 x 38.1 cm)
Bequest of Jules E. Mastbaum, F1929-7-17

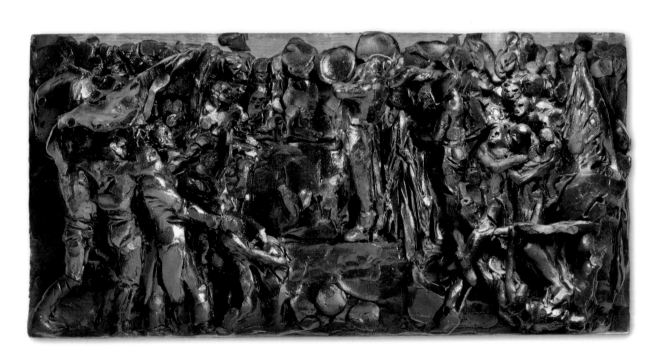

10
Scene from the French Revolution
Modeled in wax c. 1879
8 x 15 x 1¹/₂ inches (20.3 x 38.1 x 3.8 cm)
Purchased with Museum funds, 1970-4-1

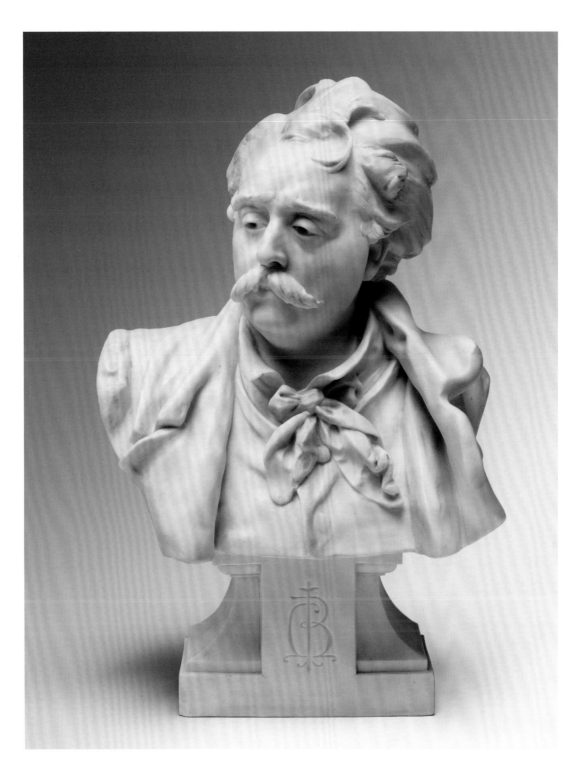

11
Albert-Ernest Carrier-Belleuse
Modeled in clay 1882
Executed in Biscuit de Sèvres porcelain by Sèvres porcelain factory
(Sèvres, France, 1756–present) 1907
14 1/2 x 9 1/2 x 5 1/2 inches (36.8 x 24.1 x 14 cm)
Bequest of Jules E. Mastbaum, F1929-7-83

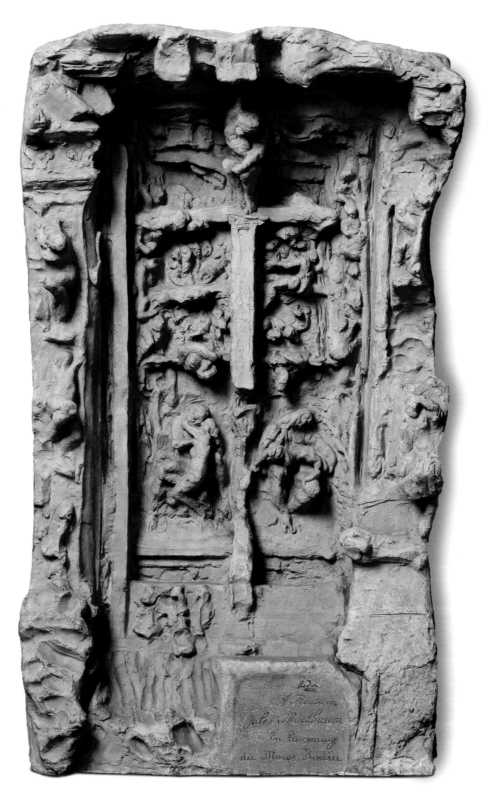

12
Third Architectural Model for "The Gates of Hell"
Modeled in clay c. 1881–82
Cast in terracotta 1926
39 1/2 x 24 3/4 x 6 3/4 inches (100.3 x 62.9 x 17.1 cm)
Gift of the estate of Jules E. Mastbaum, 1938-27-1

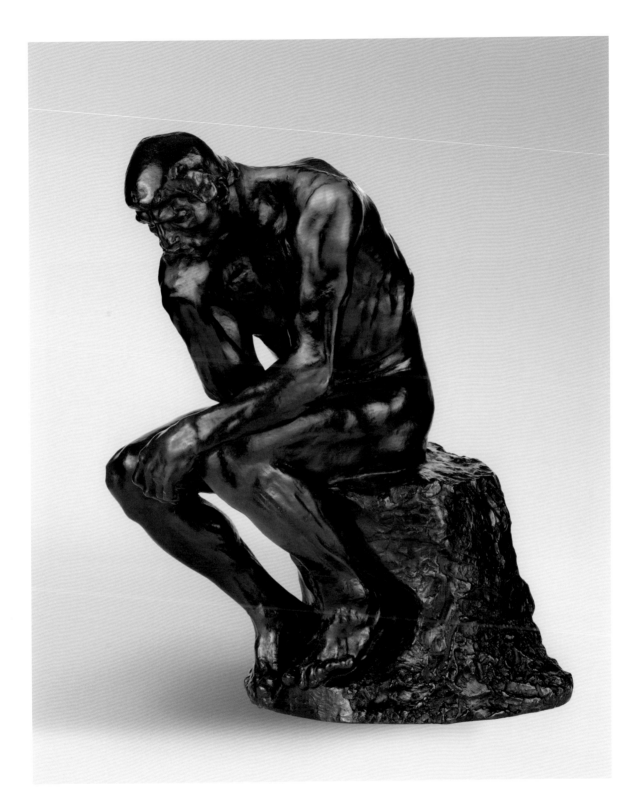

13
The Thinker
Modeled in clay 1880–81
Cast in bronze 1924
27 1/8 x 15 3/4 x 19 3/4 inches (68.9 x 40 x 50.2 cm)
Bequest of Jules E. Mastbaum, F1929-7-15

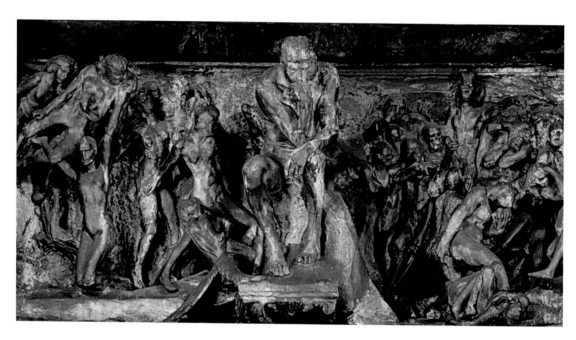

detail

14
The Gates of Hell
Modeled in clay 1880–1917
Cast in bronze 1926–28
20 feet 10 3/4 inches x 13 feet 2 inches x 33 3/8 inches
(63.7 x 40.1 x 8.5 m)
Bequest of Jules E. Mastbaum, F1929-7-128

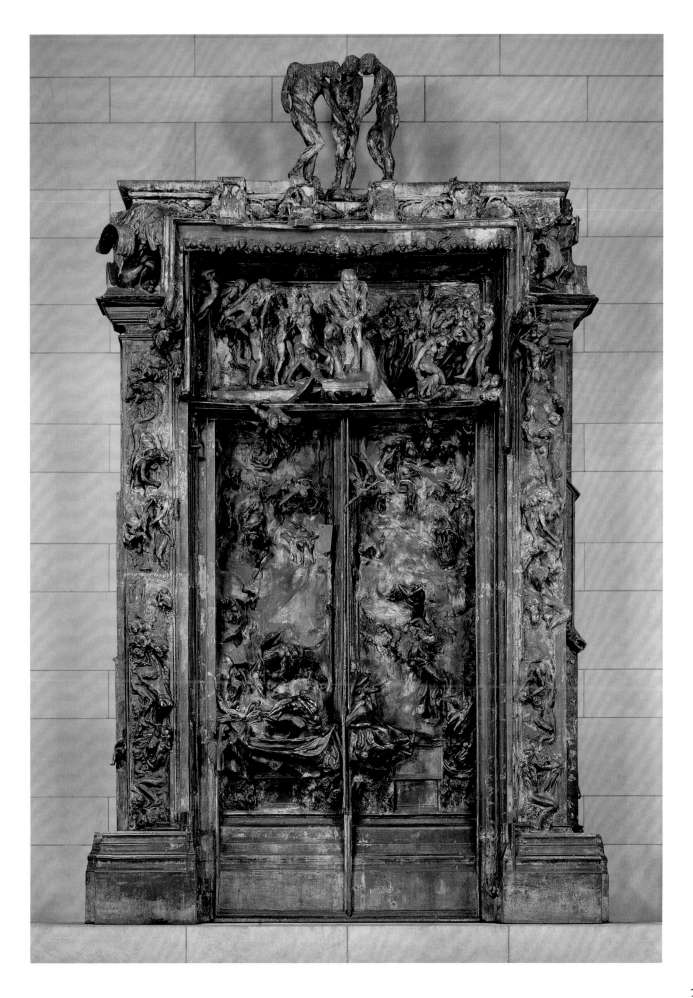

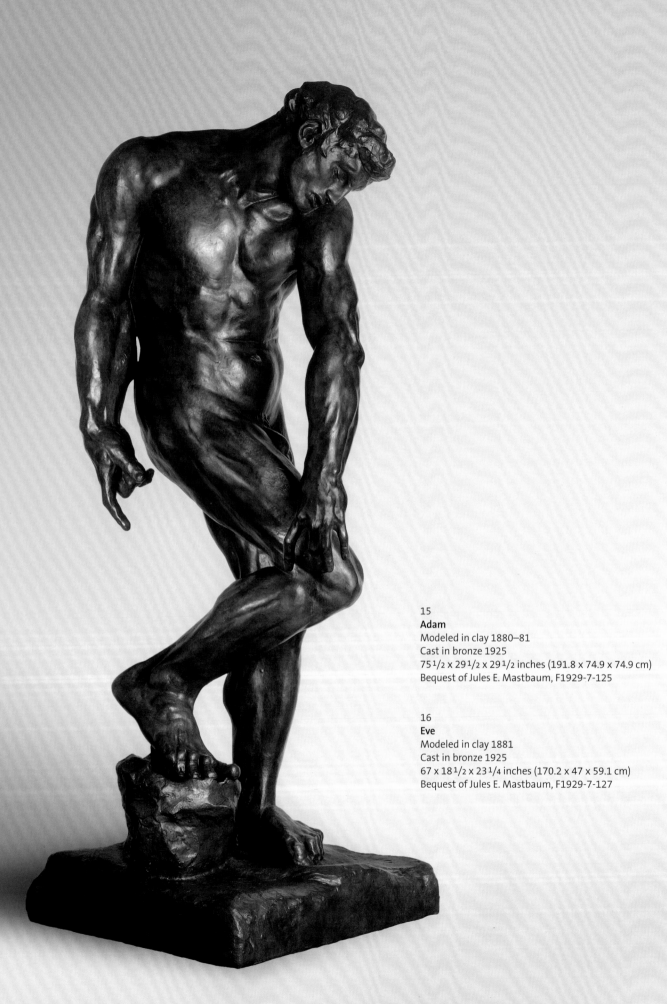

15
Adam
Modeled in clay 1880–81
Cast in bronze 1925
75 1/2 x 29 1/2 x 29 1/2 inches (191.8 x 74.9 x 74.9 cm)
Bequest of Jules E. Mastbaum, F1929-7-125

16
Eve
Modeled in clay 1881
Cast in bronze 1925
67 x 18 1/2 x 23 1/4 inches (170.2 x 47 x 59.1 cm)
Bequest of Jules E. Mastbaum, F1929-7-127

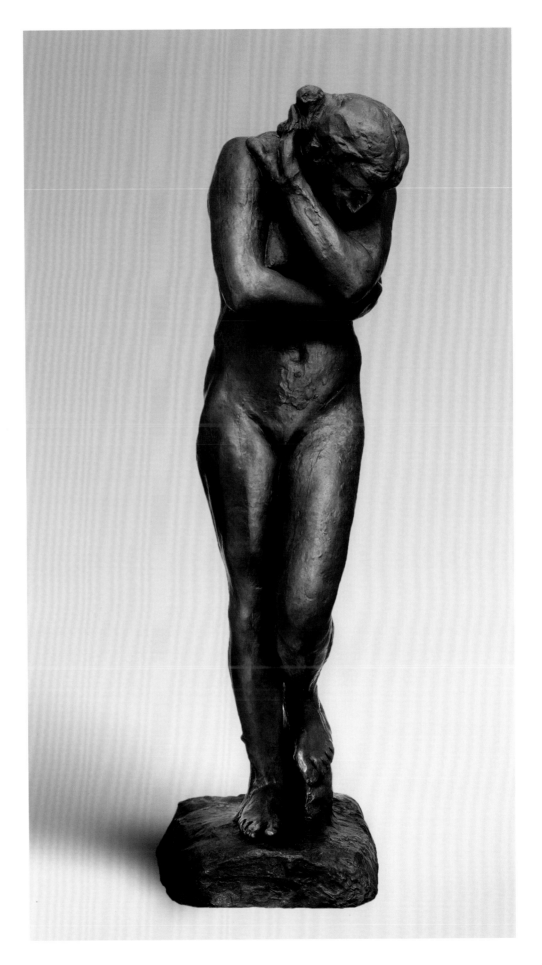

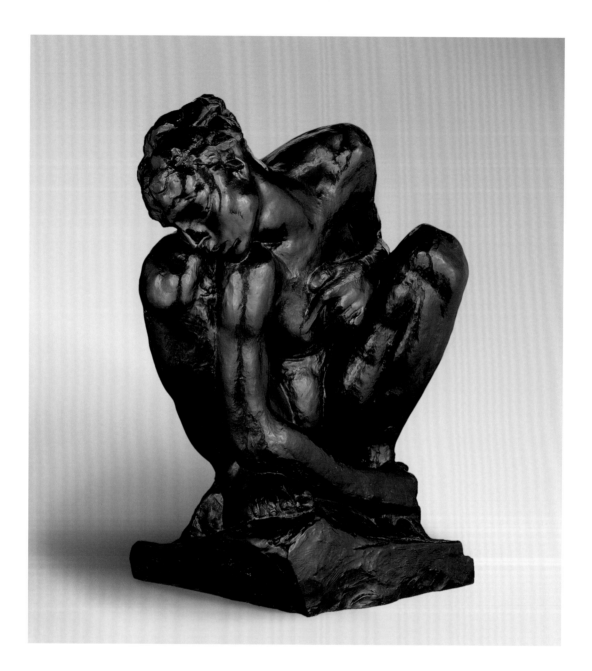

17
The Crouching Woman
Modeled in clay 1881–82, enlarged 1906–8
Cast in bronze 1925
33 x 21 x 18 inches (83.8 x 53.3 x 45.7 cm)
Bequest of Jules E. Mastbaum, F1929-7-70

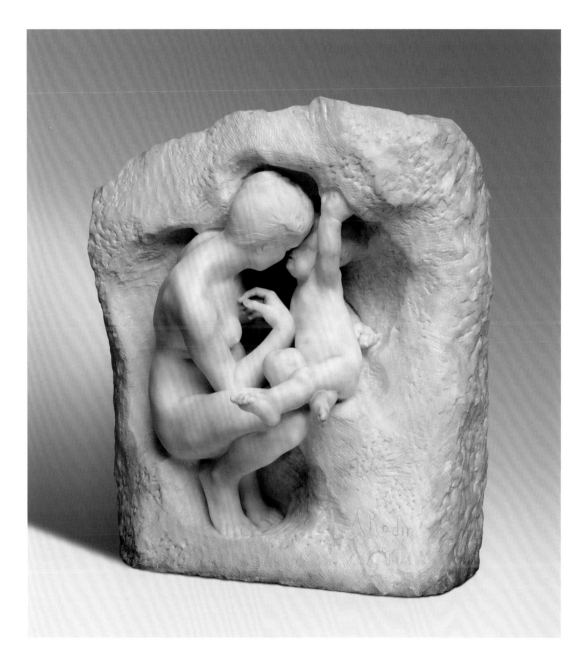

18
Young Mother in the Grotto
Modeled in clay 1885
Carved in marble by Jean Escoula (French, 1851–1911) 1893
27 7/8 x 25 5/8 x 14 9/16 inches (70.8 x 65.1 x 37 cm)
Gift of Brook J. Lenfest, 2010-11-1

19
Head of Sorrow (Joan of Arc)
Modeled in clay c. 1882, enlarged 1905
Cast in bronze 1925
17 x 19 1/2 x 21 1/4 inches (43.2 x 49.5 x 54 cm)
Bequest of Jules E. Mastbaum, F1929-7-49

20
Danaid (The Source)
Modeled in clay 1885, enlarged 1889
Carved in marble by Jean Escoula (French, 1851–1911) before 1902
13 x 19 x 25 inches (33 x 48.3 x 63.5 cm)
Gift of Alexander Harrison to the Pennsylvania Academy of the
Fine Arts in 1902 and purchased by the Philadelphia Museum of Art
with the Annenberg Fund for Major Acquisitions and other Museum
funds, 2003-4-1

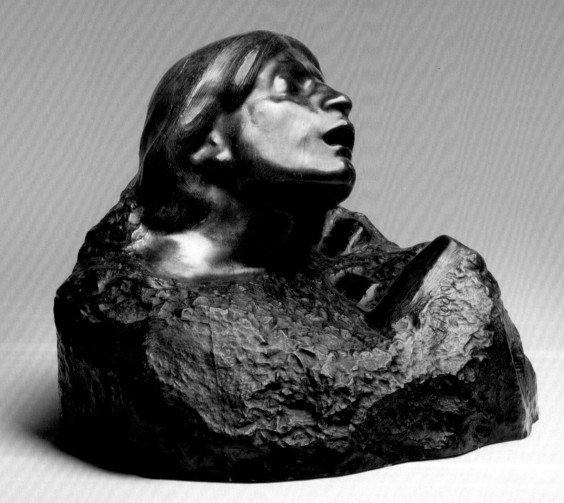

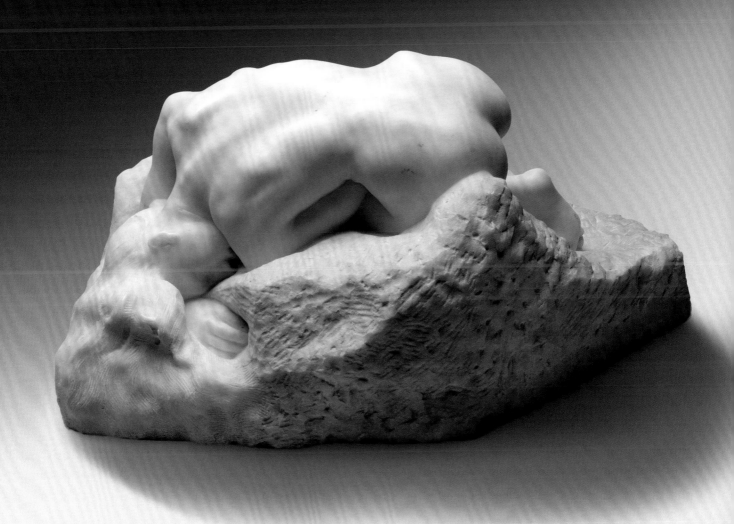

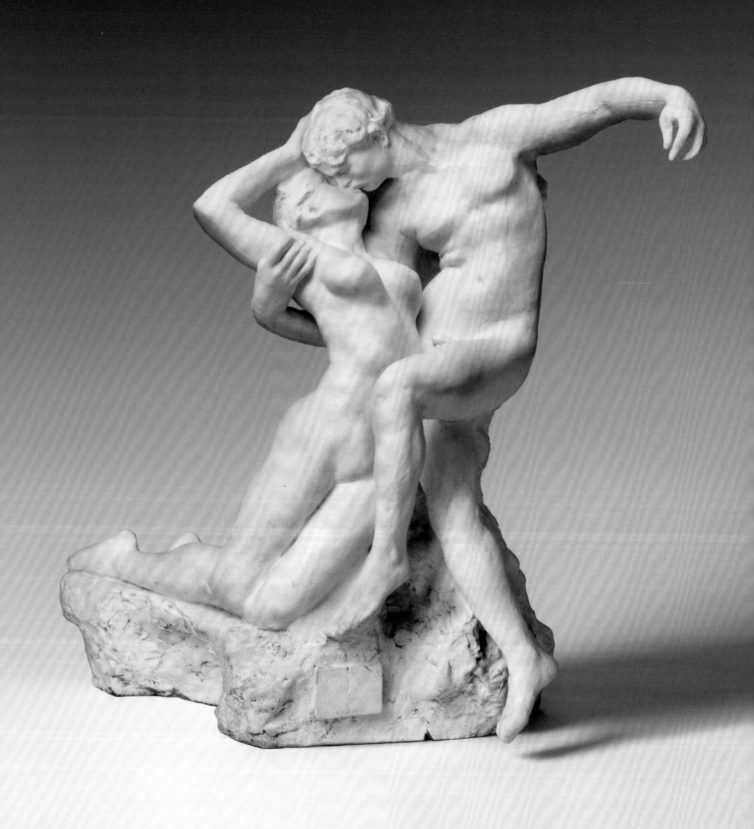

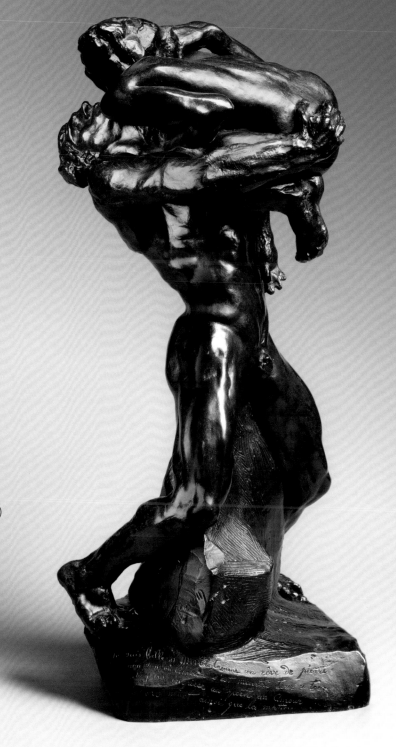

21
Eternal Springtime
Modeled in clay 1884
Cast in plaster, painted white 1885
26 x 27 5/8 x 16 5/8 inches (66 x 70.2 x 42.2 cm)
Gift of Paul Rosenberg, 1953-26-1

22
I Am Beautiful
Modeled in clay 1885
Cast in bronze 1925–26
27 3/4 x 12 x 12 1/2 inches (70.5 x 30.5 x 31.8 cm)
Bequest of Jules E. Mastbaum, F1929-7-6

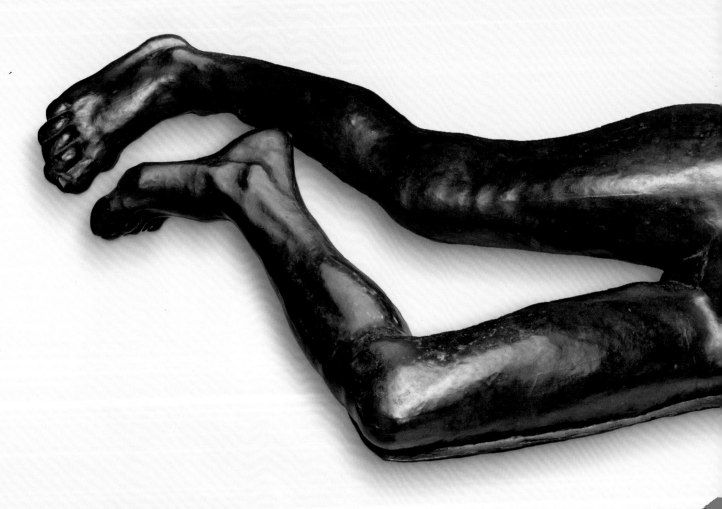

23
The Martyr
Modeled in clay 1885, enlarged 1889
Cast in bronze 1925
18 x 59 x 38 inches (45.7 x 149.9 x 96.5 cm)
Bequest of Jules E. Mastbaum, F1929-7-8

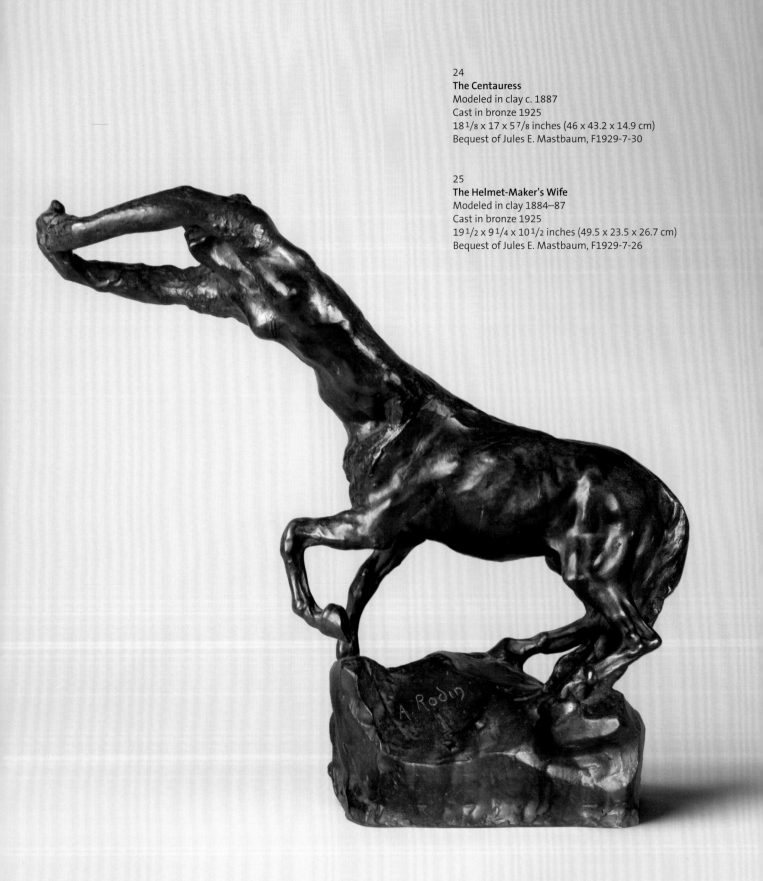

24
The Centauress
Modeled in clay c. 1887
Cast in bronze 1925
18 1/8 x 17 x 5 7/8 inches (46 x 43.2 x 14.9 cm)
Bequest of Jules E. Mastbaum, F1929-7-30

25
The Helmet-Maker's Wife
Modeled in clay 1884–87
Cast in bronze 1925
19 1/2 x 9 1/4 x 10 1/2 inches (49.5 x 23.5 x 26.7 cm)
Bequest of Jules E. Mastbaum, F1929-7-26

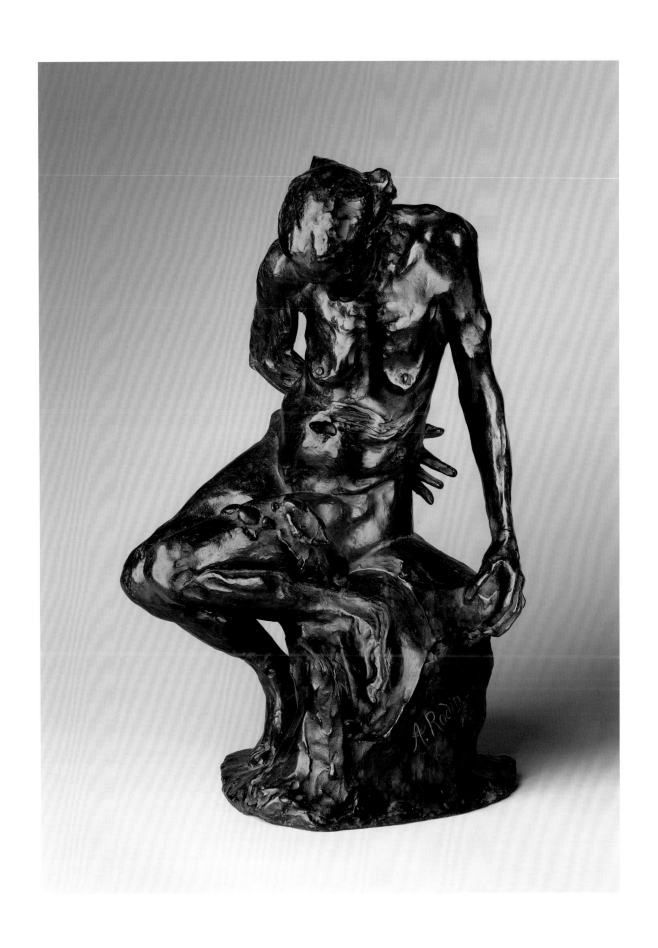

26
Bas-Relief for "The Gates of Hell" (left door)
Modeled in clay c. 1882–85
Cast in bronze 1925
12 1/2 x 43 1/2 x 5 3/4 inches (31.8 x 110.5 x 14.6 cm)
Bequest of Jules E. Mastbaum, F1929-7-83a

27
Bas-Relief for "The Gates of Hell" (right door)
Modeled in clay c. 1882–85
Cast in bronze 1925
12 1/2 x 43 1/2 x 6 1/4 inches (31.8 x 110.5 x 15.9 cm)
Bequest of Jules E. Mastbaum, F1929-7-83b

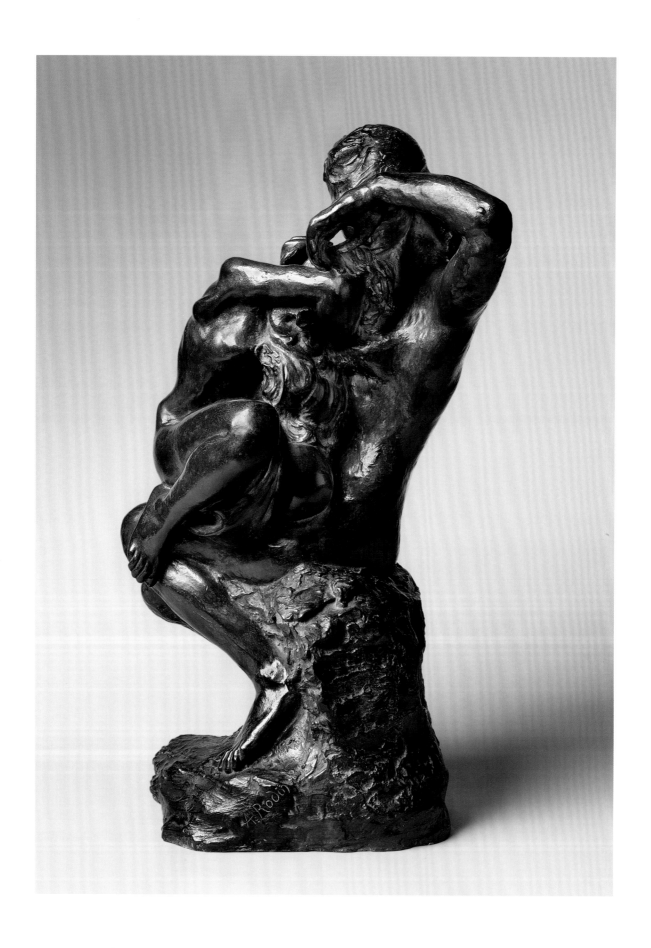

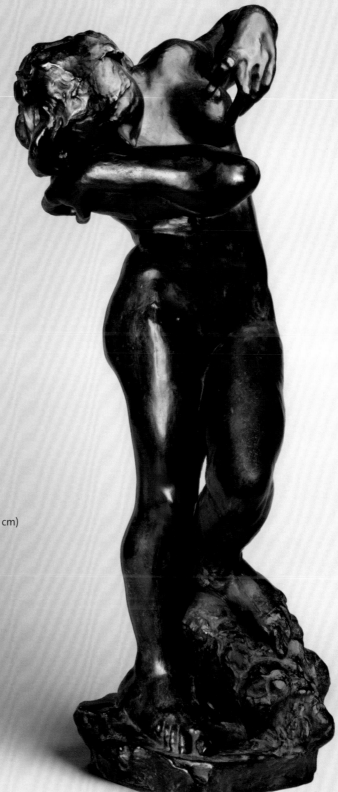

28
Shame (Absolution)
Modeled in clay c. 1885–90
Cast in bronze 1925–26
25³/₄ x 15 x 12¹/₂ inches (65.4 x 38.1 x 31.8 cm)
Bequest of Jules E. Mastbaum, F1929-7-16

29
Meditation
Modeled in clay 1885–88
Cast in bronze 1921
29 x 11 x 11 inches (73.7 x 27.9 x 27.9 cm)
Bequest of Jules E. Mastbaum, F1929-7-21

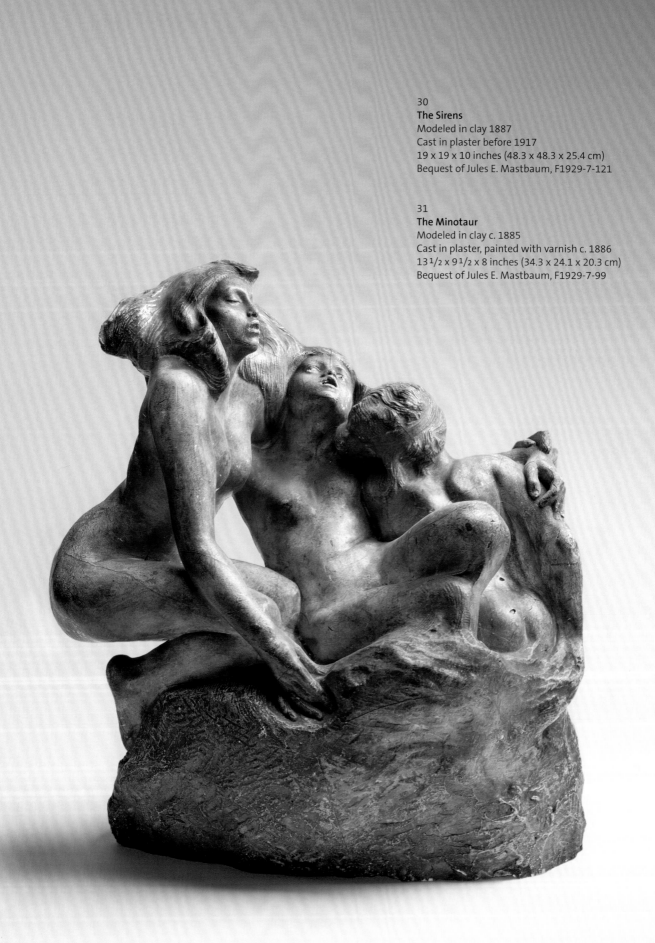

30
The Sirens
Modeled in clay 1887
Cast in plaster before 1917
19 x 19 x 10 inches (48.3 x 48.3 x 25.4 cm)
Bequest of Jules E. Mastbaum, F1929-7-121

31
The Minotaur
Modeled in clay c. 1885
Cast in plaster, painted with varnish c. 1886
13 1/2 x 9 1/2 x 8 inches (34.3 x 24.1 x 20.3 cm)
Bequest of Jules E. Mastbaum, F1929-7-99

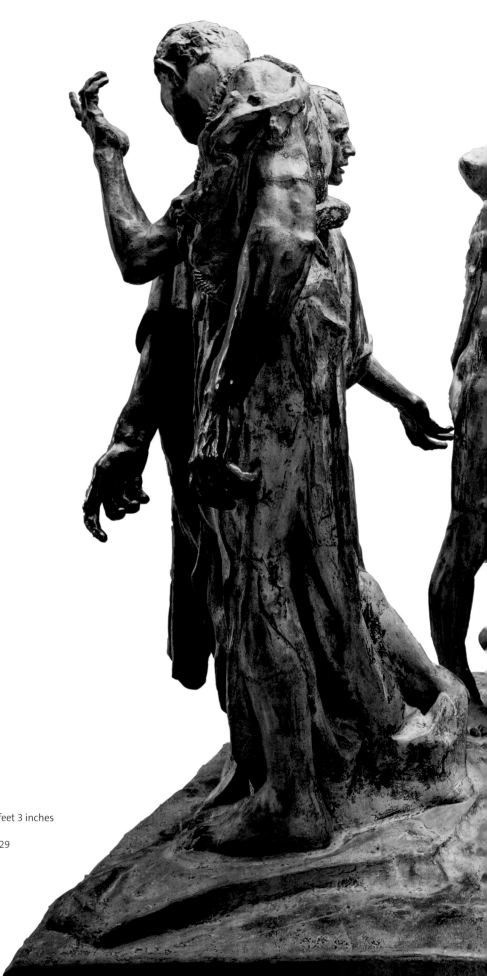

32
The Burghers of Calais
Modeled in clay 1884–95
Cast in bronze 1919–21
6 feet 10 1/2 inches x 7 feet 10 inches x 6 feet 3 inches
(21 x 23.9 x 19 m)
Bequest of Jules E. Mastbaum, F1929-7-129

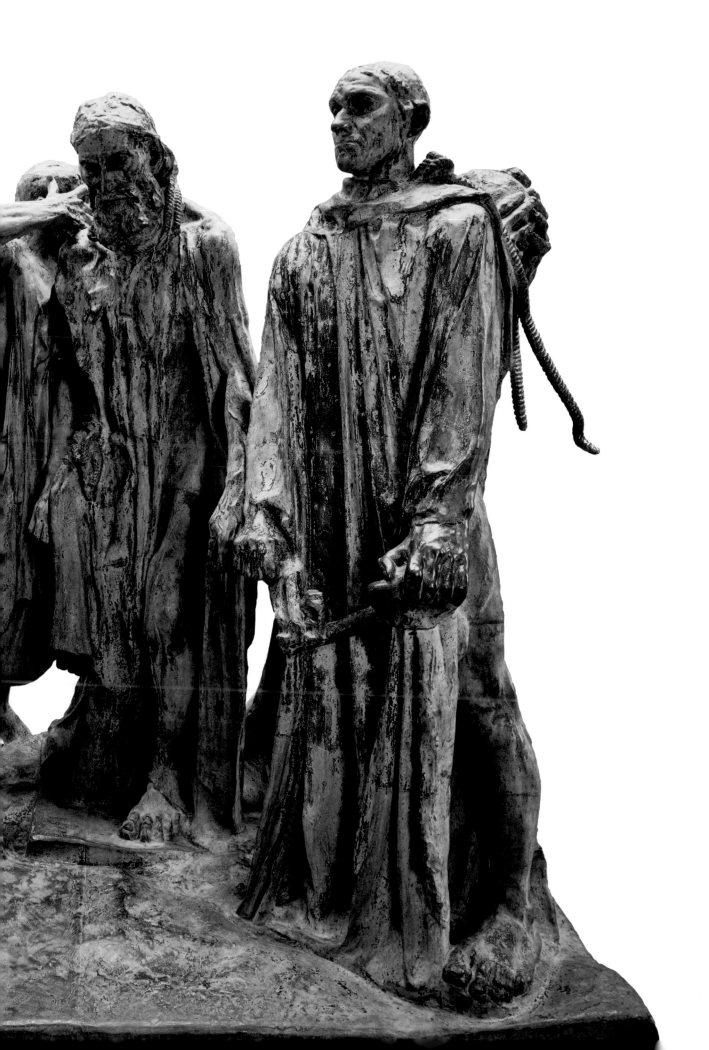

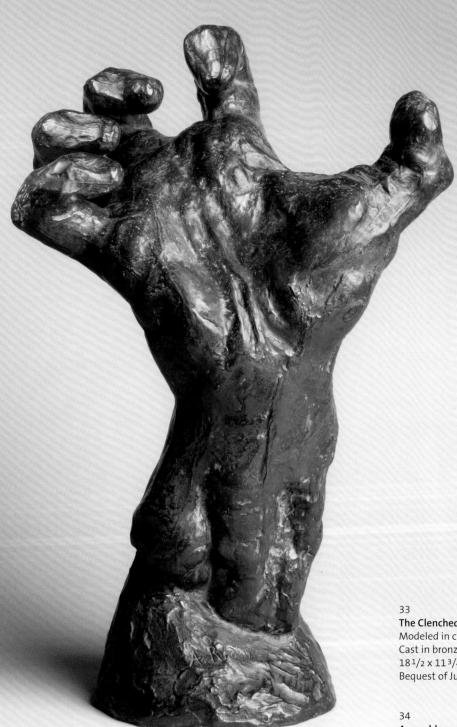

33
The Clenched Hand
Modeled in clay c. 1885
Cast in bronze 1925
18 1/2 x 11 3/4 x 8 inches (47 x 29.8 x 20.3 cm)
Bequest of Jules E. Mastbaum, F1929-7-29

34
Assemblage of Heads of "The Burghers of Calais"
Modeled in clay late 1880s
Cast in plaster 1926
9 1/2 x 11 x 9 1/4 inches (24.1 x 27.9 x 23.5 cm)
Bequest of Jules E. Mastbaum, F1929-7-92

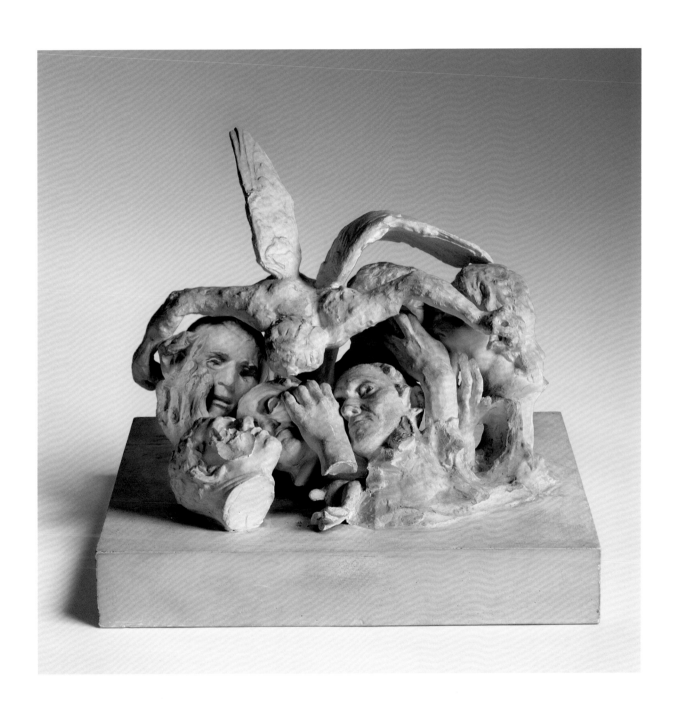

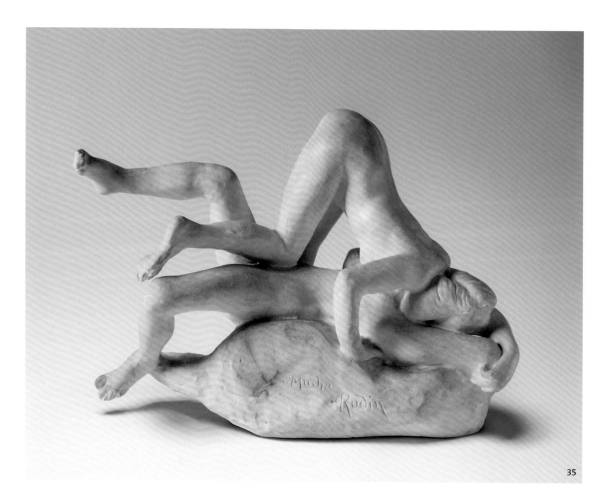

35

35
Damned Women
Modeled in clay 1885
Cast in plaster 1927
8 1/8 x 11 1/4 x 5 inches (20.6 x 28.6 x 12.7 cm)
Bequest of Jules E. Mastbaum, F1929-7-113

36
Possession
Modeled in clay c. 1895–97
Cast in plaster 1927
9 1/4 x 4 3/4 x 4 1/2 inches (23.5 x 12.1 x 11.4 cm)
Bequest of Jules E. Mastbaum, F1929-7-90

37
Polyphemus
Modeled in clay 1888
Cast in plaster before 1895
9 3/4 x 6 x 5 3/4 inches (24.8 x 15.2 x 14.6 cm)
Bequest of Jules E. Mastbaum, F1929-7-97

38
Headless Woman Bending Over
Modeled in clay mid-1880s
Cast in plaster before 1909
9 x 6 1/2 x 5 inches (22.9 x 16.5 x 12.7 cm)
Bequest of Jules E. Mastbaum, F1929-7-96

39
Hanako
Modeled in clay 1907
Cast in plaster by 1929
6 3/4 x 4 3/4 x 4 5/8 inches (17.1 x 12.1 x 11.7 cm)
Bequest of Jules E. Mastbaum, F1929-7-87

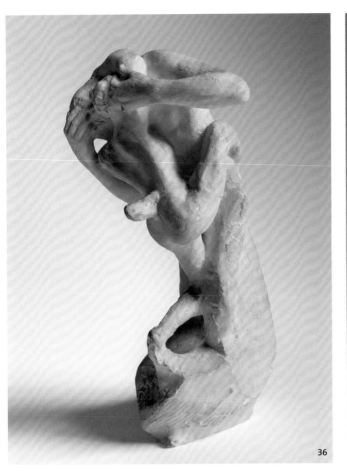

36

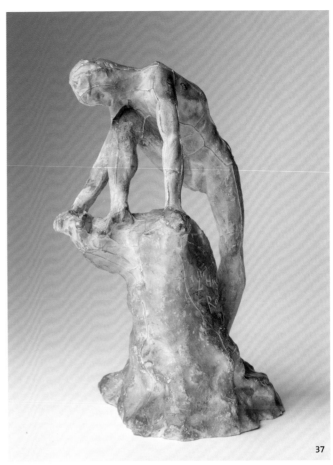

37

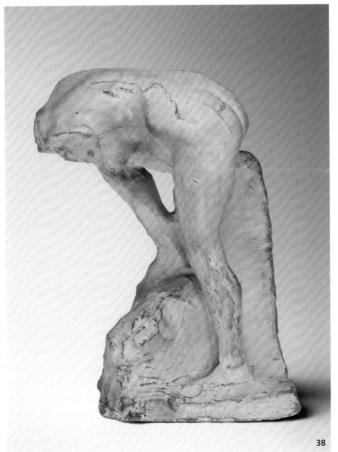

38

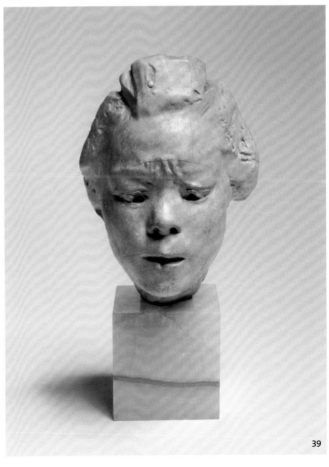

39

63

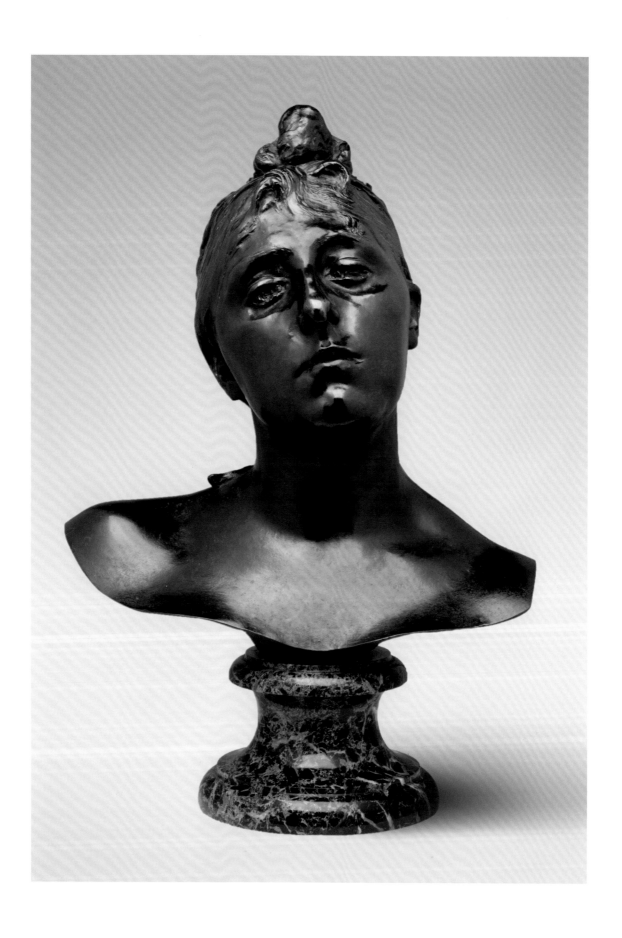

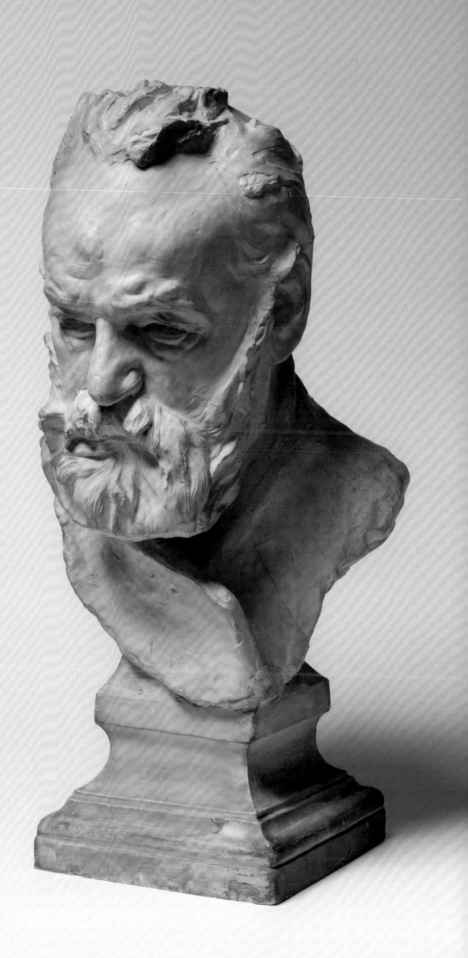

40
Madame Vicuña
Modeled in clay 1887
Cast in bronze 1925
14 1/4 x 14 x 10 inches (36.2 x 35.6 x 25.4 cm)
Bequest of Jules E. Mastbaum, F1929-7-59

41
Victor Hugo
Modeled in clay 1883
Cast in plaster 1886
22 1/4 x 10 x 11 1/2 inches (56.5 x 25.4 x 29.2 cm)
Bequest of Jules E. Mastbaum, F1929-7-85

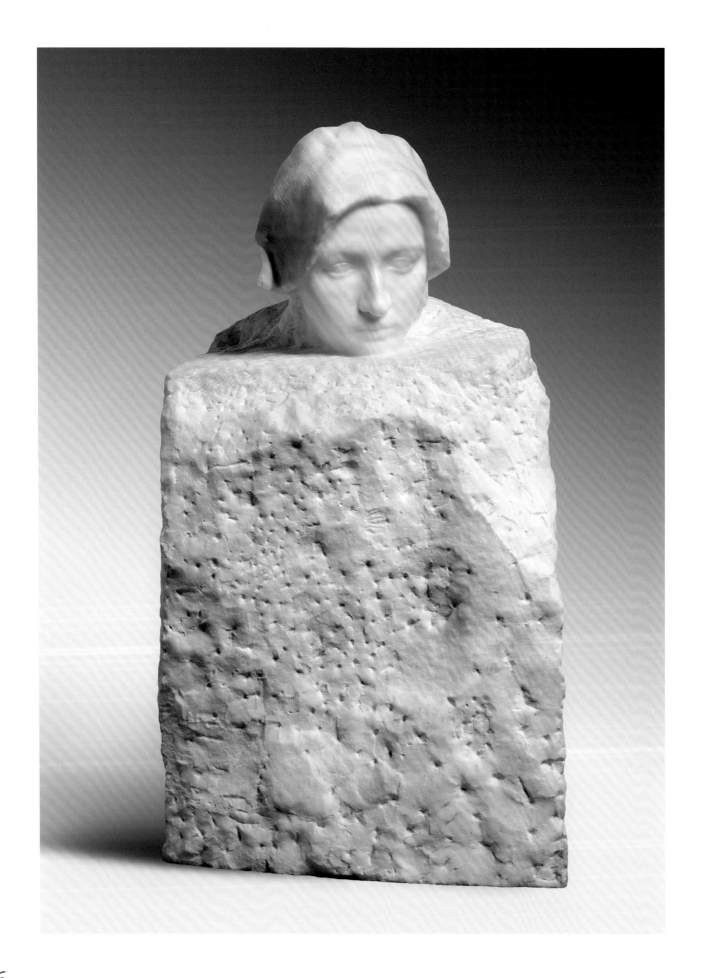

42
Thought
Modeled in clay 1895
Carved in marble by Camille Raynaud (French, 1868–after 1931)
1900–1901
29 1/8 x 17 1/16 x 18 1/8 inches (74 x 43.4 x 46.1 cm)
John G. Johnson Collection, cat. 1148

43
The Athlete
Modeled in clay 1901
Cast in bronze 1925
16 7/8 x 12 1/2 x 11 1/4 inches (42.9 x 31.8 x 28.6 cm)
Bequest of Jules E. Mastbaum, F1929-7-4

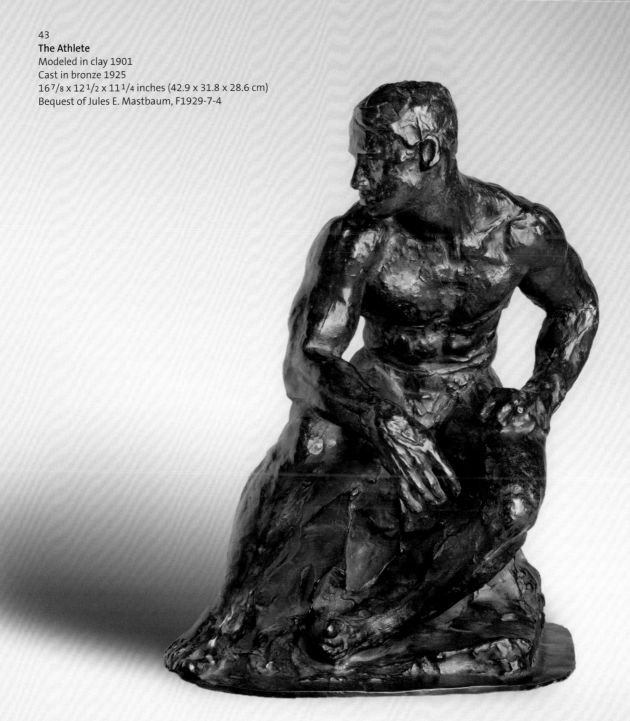

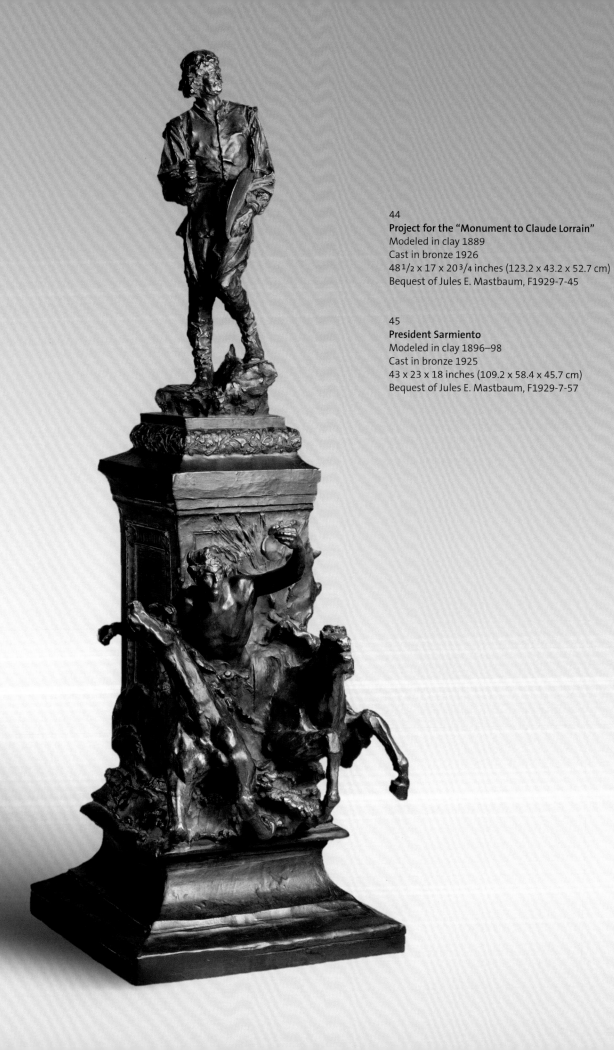

44
Project for the "Monument to Claude Lorrain"
Modeled in clay 1889
Cast in bronze 1926
48^{1}/$_{2}$ x 17 x 20^{3}/$_{4}$ inches (123.2 x 43.2 x 52.7 cm)
Bequest of Jules E. Mastbaum, F1929-7-45

45
President Sarmiento
Modeled in clay 1896–98
Cast in bronze 1925
43 x 23 x 18 inches (109.2 x 58.4 x 45.7 cm)
Bequest of Jules E. Mastbaum, F1929-7-57

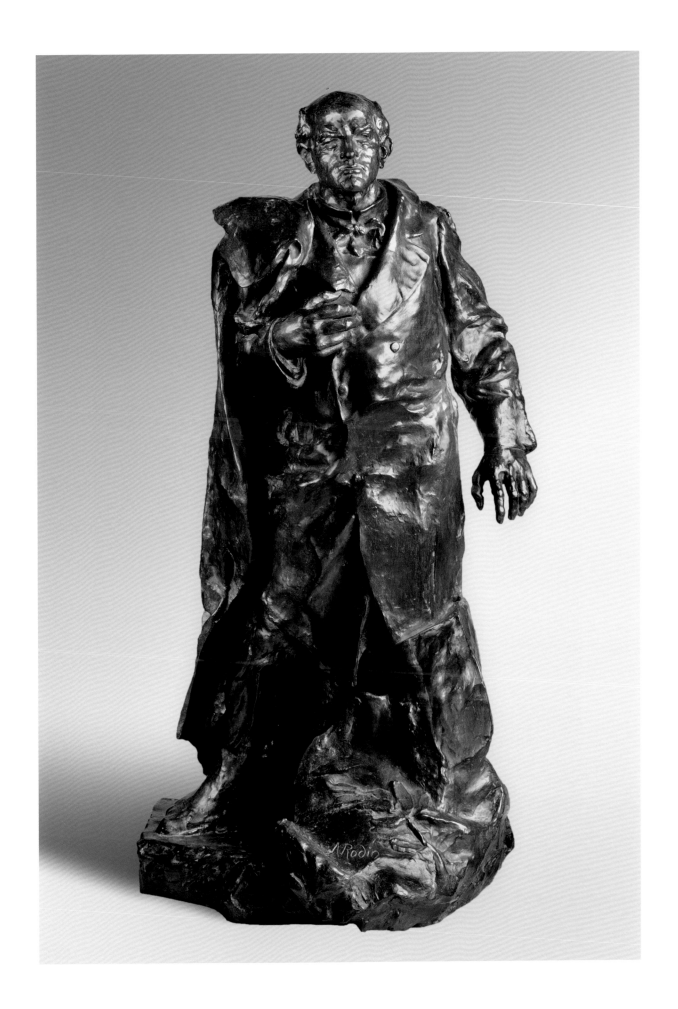

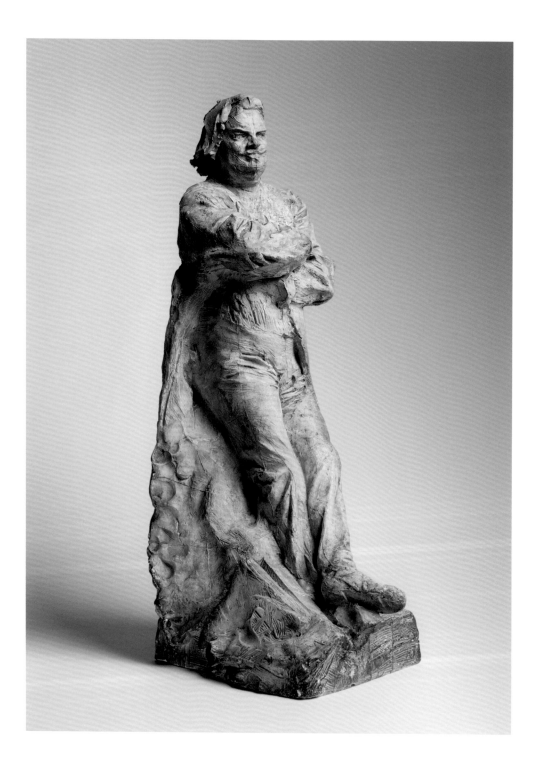

46
Balzac in a Frock Coat, Leaning against a Pile of Books
Modeled in clay 1891
Cast in plaster before 1917
25 3/8 x 9 1/2 x 11 3/4 inches (64.5 x 24.1 x 29.8 cm)
Bequest of Jules E. Mastbaum, F1929-7-111

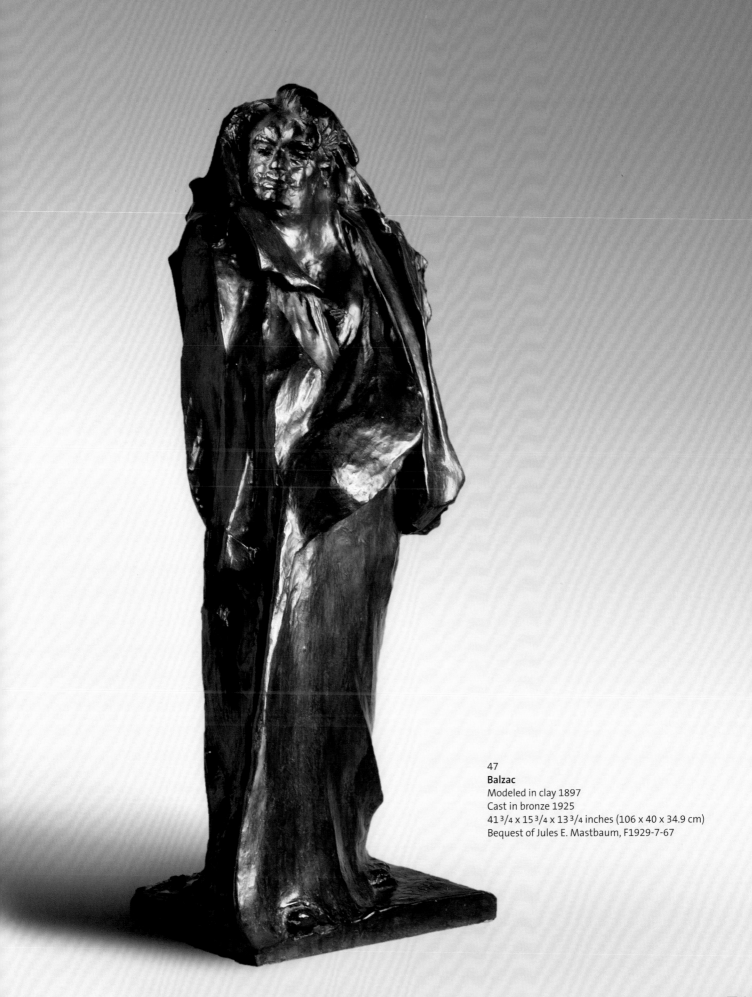

47
Balzac
Modeled in clay 1897
Cast in bronze 1925
41 ³/₄ x 15 ³/₄ x 13 ³/₄ inches (106 x 40 x 34.9 cm)
Bequest of Jules E. Mastbaum, F1929-7-67

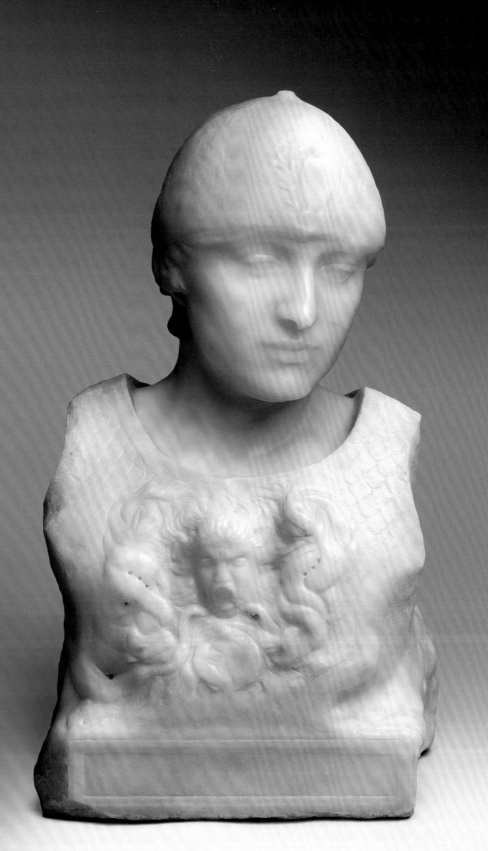

48
Minerva
Modeled in clay c. 1898
Carved in marble by Camille Raynaud (French, 1868–after 1931) 1901
22 1/2 x 12 1/4 x 11 1/2 inches (57.2 x 31.1 x 29.2 cm)
Bequest of Jules E. Mastbaum, F1929-7-54

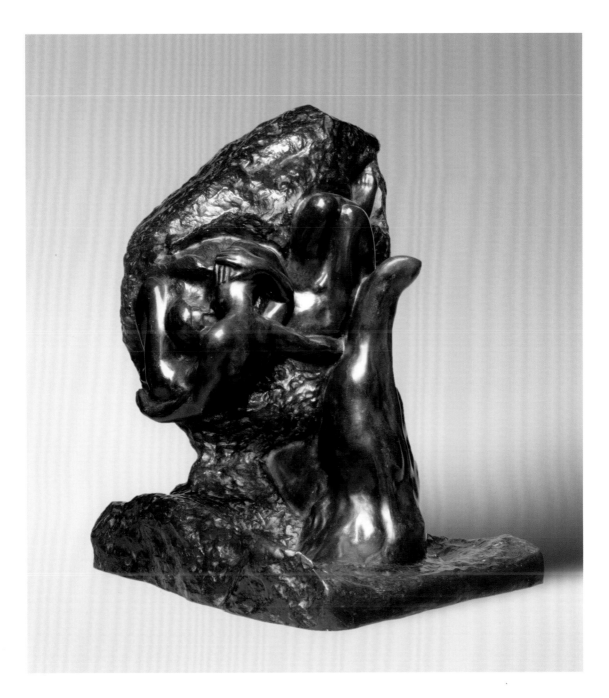

49
The Hand of God
Modeled in clay 1898
Cast in bronze 1925
26 3/4 x 17 1/2 x 21 1/2 inches (67.9 x 44.4 x 54.6 cm)
Bequest of Jules E. Mastbaum, F1929-7-69

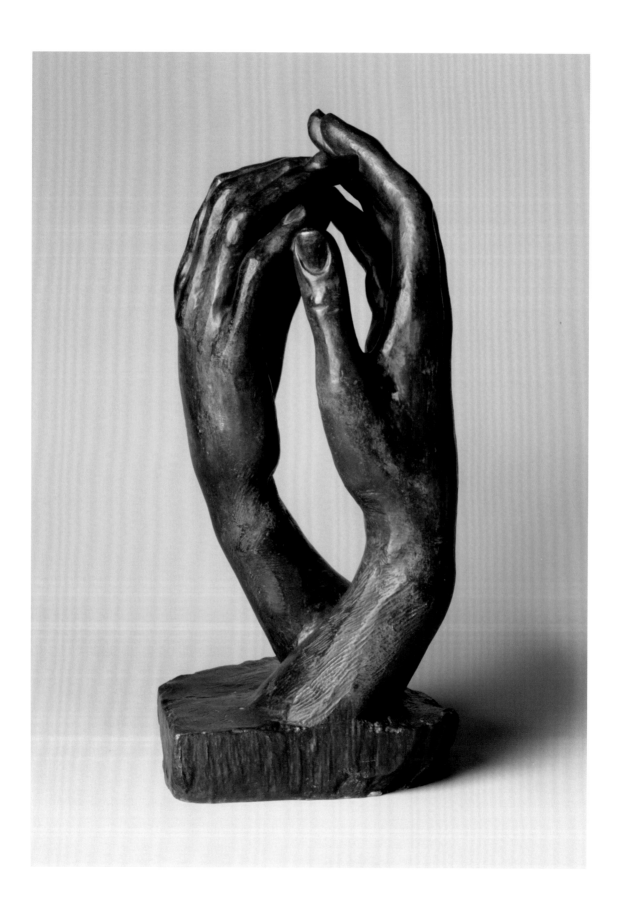

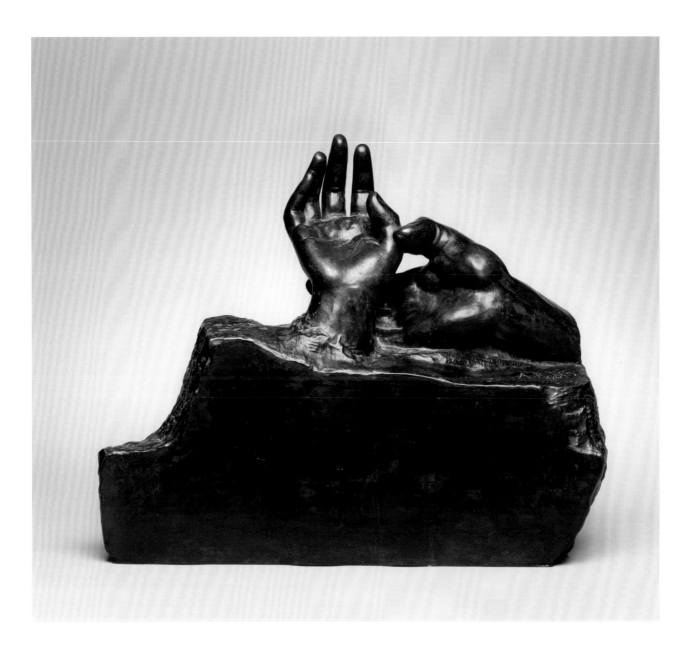

50
The Cathedral
Modeled in clay 1908
Cast in bronze 1925
24 1/2 x 10 3/4 x 11 3/4 inches (62.2 x 27.3 x 29.8 cm)
Bequest of Jules E. Mastbaum, F1929-7-40

51
Two Hands
Modeled in clay before 1909
Cast in bronze 1925
18 x 20 7/8 x 12 3/4 inches (45.7 x 53 x 32.4 cm)
Bequest of Jules E. Mastbaum, F1929-7-20

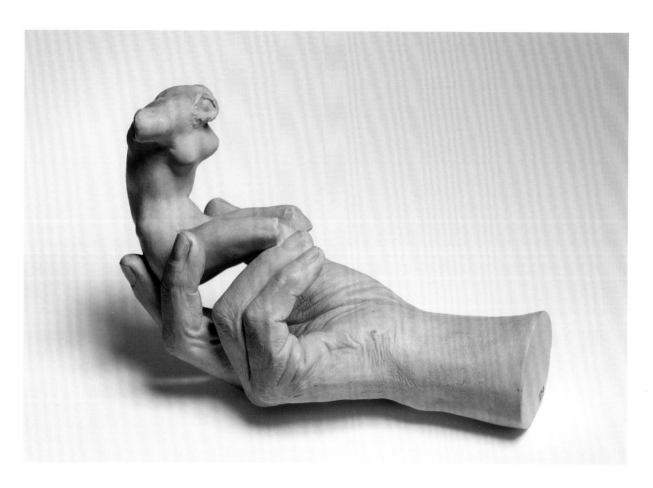

52
Auguste Rodin and Paul Cruet (French, 1880–1966)
Hand of Rodin Holding a Torso
Cast in plaster 1917
6 1/4 x 9 x 3 3/4 inches (15.9 x 22.9 x 9.5 cm)
Bequest of Jules E. Mastbaum, F1929-7-109

53
Mask of Hanako
Modeled in clay c. 1907
Executed in *pâte-de-verre* (ground glass refired in a mold) 1911
8 5/8 x 4 3/4 x 3 1/2 inches (21.9 x 12.1 x 8.9 cm)
Bequest of Jules E. Mastbaum, F1929-7-43b

54
The Secret
Modeled in clay 1910
Cast in bronze 1925
33 1/2 x 19 x 15 1/4 inches (85.1 x 48.3 x 38.7 cm)
Bequest of Jules E. Mastbaum, F1929-7-52

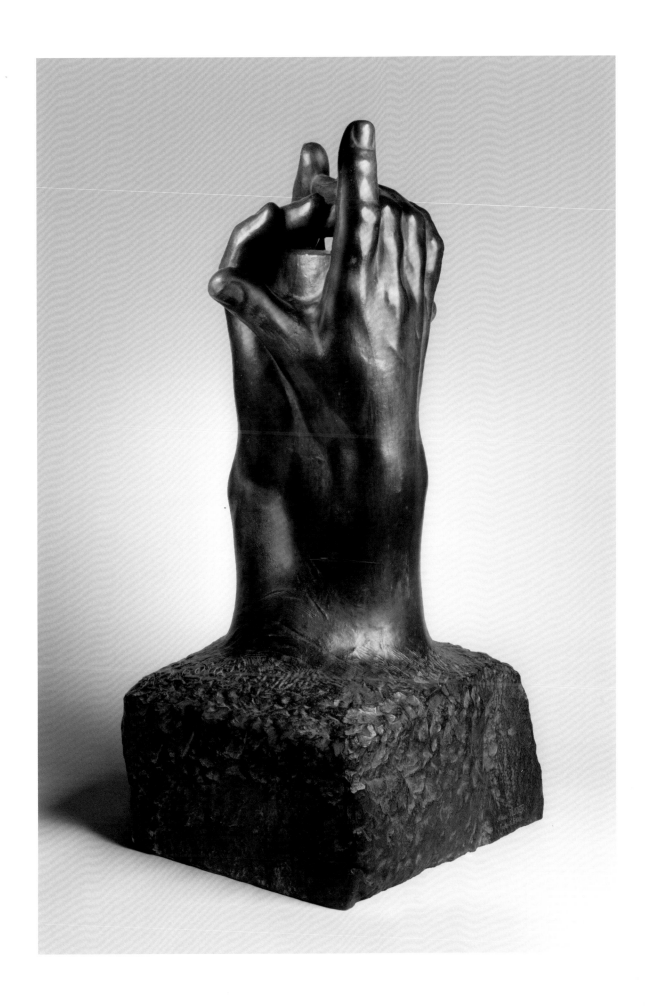

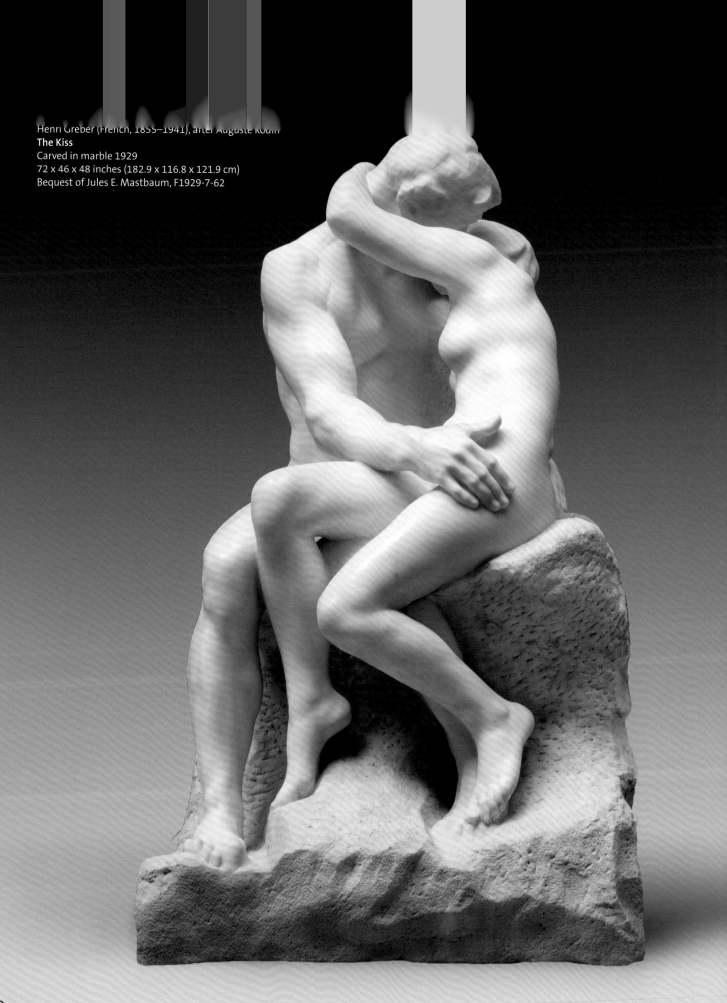

Henri Greber (French, 1855–1941), after Auguste Rodin
The Kiss
Carved in marble 1929
72 x 46 x 48 inches (182.9 x 116.8 x 121.9 cm)
Bequest of Jules E. Mastbaum, F1929-7-62

Index of Works Illustrated

Plate numbers are in bold.

Produced by the Publishing Department
Philadelphia Museum of Art
Sherry Babbitt
The William T. Ranney Director of Publishing
2525 Pennsylvania Avenue
Philadelphia, PA 19130-2440 USA
www.philamuseum.org

Edited by Sherry Babbitt
Production by Richard Bonk
Designed by Lisa Benn Costigan
Printed and bound in Canada by Transcontinental Litho Acme,
Montreal

Front cover: Detail of the Meudon Gate with *The Thinker*, 2012
Back cover: *Eve* in the façade of the Rodin Museum, 2012
Endpapers: Plans for pedestals at the Rodin Museum by Paul
Philippe Cret and Jacques Gréber Associated Architects, August
1929 (Cret Collection, CRE176-089 [front] and CRE176-090 [back],
The Athenaeum of Philadelphia)
Title page: Interior of the Rodin Museum, 2012
Page 80: Shell-shaped fountain, designed by Paul Philippe Cret, in
the reflecting pool of the Rodin Museum, 2012

All color photography by Graydon Wood except front and back
covers, pp. 4–5, 8–9, fig. 12: Constance Mensh; pl. 5: Jason
Wierzbicki

Library of Congress Control Number: 2012946556

ISBN 978-0-87633-241-2

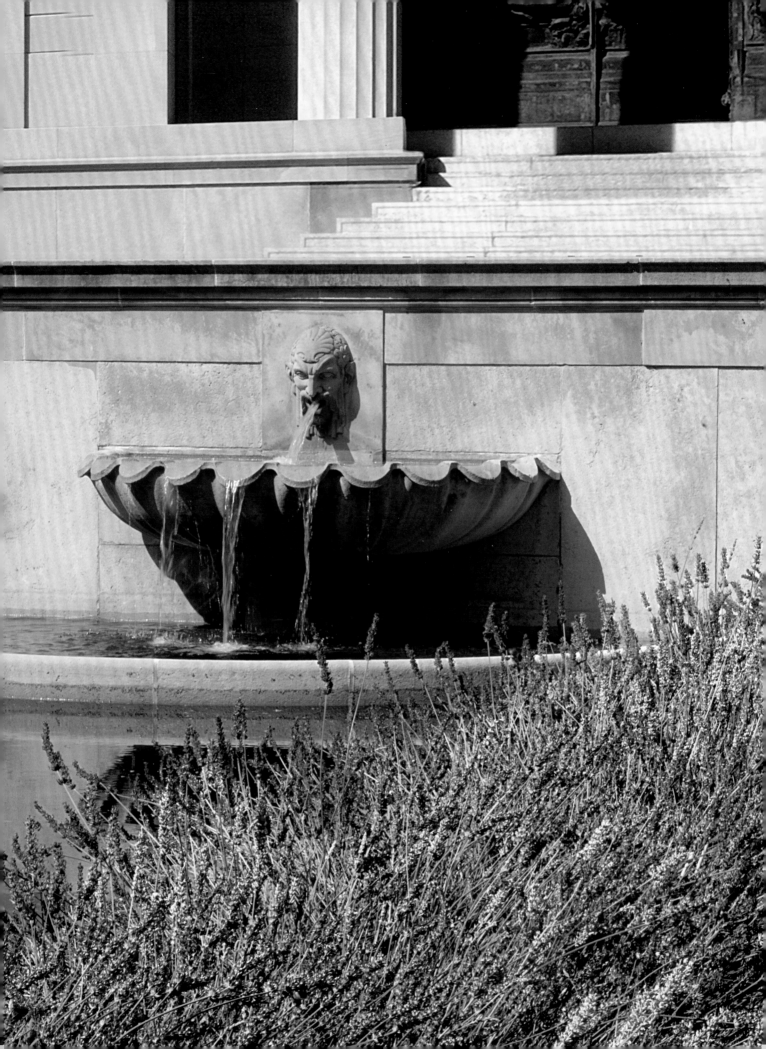

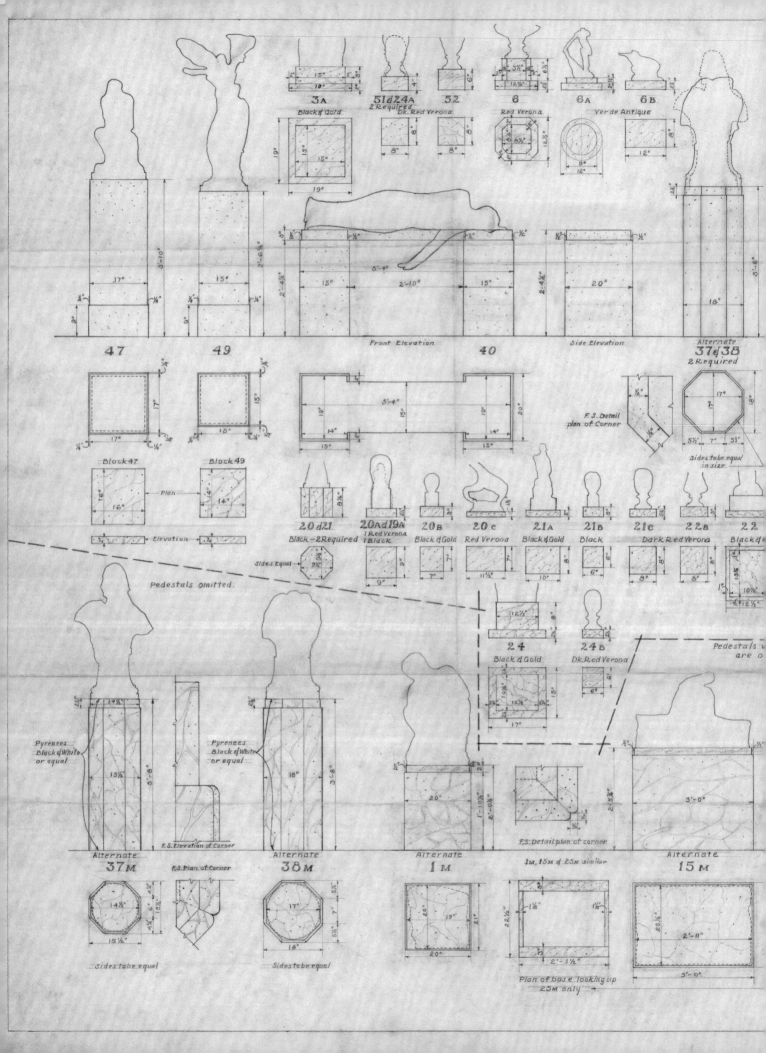

3A
Black & Gold

51 & 24A
2 Required
Dk. Red Verona

52

6
Red Verona

6A

6B
Verde Antique

47

49

Front Elevation

40

Side Elevation

Alternate
37 & 38
2 Required

Block 47

Block 49

Plan

Elevation

F.S. Detail
plan of Corner

Sides to be equal
in size

Pedestals omitted.

20 & 21
Black – 2 Required

20A & 19A
1 Red Verona
1 Black

20B
Black & Gold

20 c
Red Verona

21A
Black & Gold

21B
Black

21c
Dark Red Verona

22B

22
Black & Gold

Sides Equal

24
Black & Gold

24B
Dk. Red Verona

Pedestals
are o

Pyrenees
Black & White
or equal

Pyrenees
Black & White
or equal

F.S. Elevation of Corner

F.S. Detail plan of corner

Alternate
37M

F.S. Plan of Corner

Alternate
38M

Alternate
1 M

1M, 15M & 25M similar

Alternate
15 M

Sides to be equal

Sides to be equal

Plan of base looking up
25M only